The Eric Kundur Memorial Library

CREATIVE PHOTOGRAPHIC
EFFECTS SIMPLIFIED

2

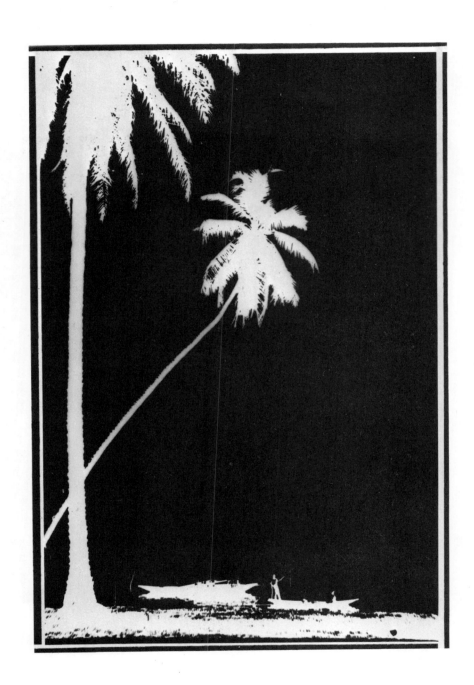

A MODERN PHOTOGUIDE
CREATIVE PHOTOGRAPHIC
EFFECTS SIMPLIFIED

by

Paul Duckworth

AMPHOTO
Garden City, New York 11530

**To
Marion
with
Love**

CONTENTS

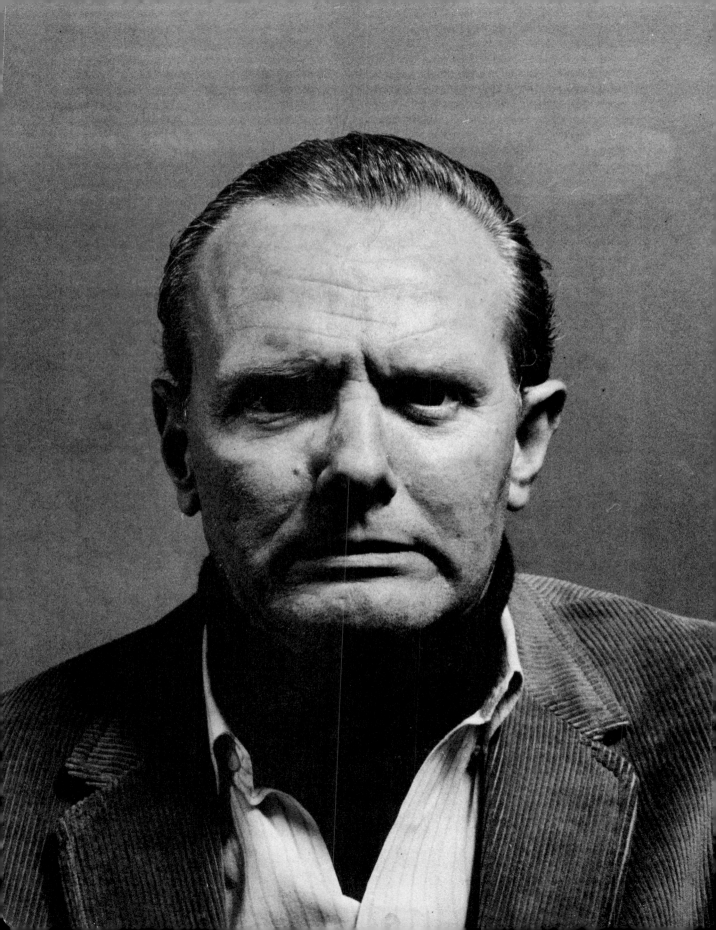

FOREWORD

When I sat down to write this book, I didn't know exactly how to begin. Before I realized it, three hours had gone by while I stared out the window at the passing world. By then, however, I knew what I wanted to say. There is no better advice that I can give any photographer:

Stop staring out the window and get to work, or the world will pass you by!

When you set out on the exciting road to trick and experimental photography, I must assume that you are already familiar with the most important tricks of seeing, lighting, composition, posing, arrangement, proper film and developer combinations, and of course, that trick of tricks, darkroom mastery. It is pointless to learn a new technique if you haven't mastered the old ones.

Never—but never—let yourself get sucked into the "automation" syndrome. If you intend to be a photographer of substance, then the techniques of photography should fit like a second skin. When you can go through the mechanics of exposure, lighting, shooting, developing, and printing effortlessly, then you will be free to think creatively. No artists could paint masterpieces if they stood before their easels pondering which colors were required for a particular tint, which brushes to use, and how to convey on canvas the pictures they conceived. By the same token, if you always send your negatives to be printed in a lab, how will you ever be able to perform a new printing technique?

Recently I read an article extolling the virtues and technical achievements of various pieces of expensive equipment. My opinion has always been that it is not the price you pay for your equipment nor is it bench-testing that makes masterpieces. Rather, it is your ability to use what you have to best advantage. Indeed, I have a lens that I made for less than a dollar. It provides me with special effects obtainable with no other lens, no matter what the price.

How can you get the most out of your equipment? First, you must love your craft, and you must take pride in your finished product. Many practitioners are more concerned with impressing others by a glittering display of equipment or by dancing around, knocking off fantastic shots from weird camera angles. I know one guy who is always seen shooting with a long telephoto and hand-holding his camera when the situation calls for a tripod. When asked about his pictures, he claims he doesn't understand why they never come out. However, he believes that if he fires away with his camera, he'll look like a TV hero. What I'm trying to say is that *you* must be your strongest critic, and only you can judge the fin-

I took this self-portrait in order to get a bad picture rather than a good one. My first intention was to use the photograph as the underpart of a silk-screen print, so I mounted about 20 prints. Then I decided to paint them with oil paint. I mixed my paint with a paint medium, which acted as a splendid binder for the paint and gave me a satin-gloss finish. I wanted to alter the photograph as little as possible, while changing the character as much as possible to show the many sides of man's personality. The technique is so simple that a child should be able to do it. I started with the background, then painted out the turtleneck sweater and jacket. Then I either added or took away the hair and made minor alterations on the face. Lightening the eyes made them look holy, while darkening them made them look sinister. It was not my intention to try to pass these off as art but merely as fun things to do. They were so successful that I was commissioned to do a series for a TV personality, and I appeared as a guest on the program. See the cover and color section for pictures done using this technique.

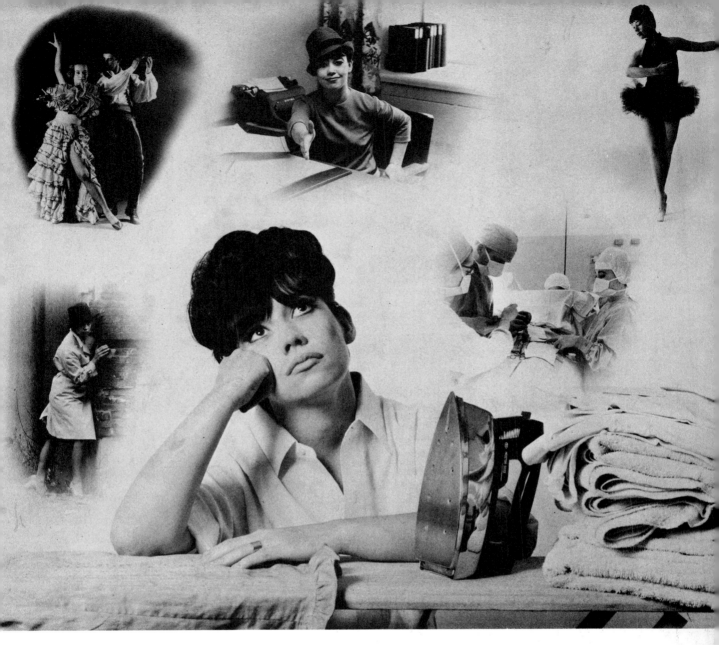

(Above) When asked to illustrate a magazine story about women who often feel trapped as housewives, I dug into my voluminous files and found that I had many photographs of my lovely wife that were perfect for the magazine story. I photographed her at an ironing board as though she were daydreaming, then I printed pictures of her as a nurse, a ballet dancer, a businesswoman, a flamenco dancer, and a spy.

(Left) Curiosity is often a short way to an experiment. One evening I removed the lens from my enlarger, replaced it with a large magnifying glass, and made a few prints. I found that only one point in the picture could be focused sharply while the rest of the picture fell away, getting softer and softer toward the edges. I like the effect on this picture of my daughter, Leslie, holding a flower, as well as this Repolith of the moon and seagulls.

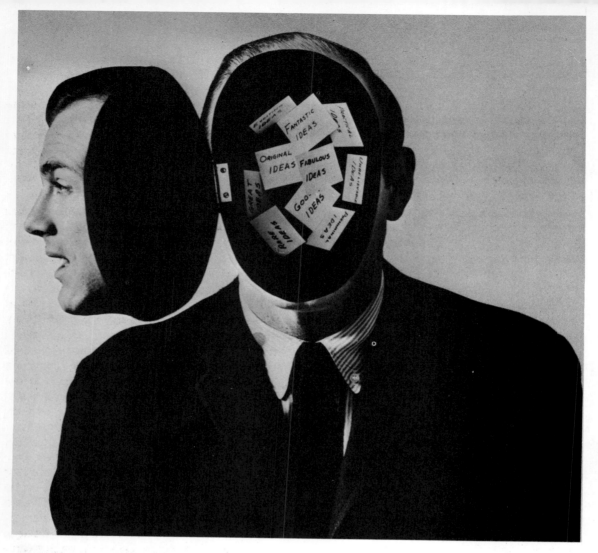

One day my agent went to an ad agency to try to get a new account. The art director asked if I had any good ideas for pictures. When my agent relayed the message to me, I set to work on this picture. I wrote all kinds of ideas on cards and placed them in a black hat. I then put a hinge on the edge of the hat with a piece of black cardboard, photographed this against a white background, and photographed my agent straight-on and profile. I printed the straight-on picture and pasted up the profile and the black hat full of cards. My agent took this picture back to the client.

ished product. Many, many times I've had photographers come to show me a "really great shot," which I felt was either a lousy print or too dark, too light, out of focus, blurred, or someone got in the way. It is hard for them to realize that although they may have seen a great shot, they failed miserably to capture it. I used to keep a print of a blurred train for these occasions. After viewing such a "masterpiece" I would say, "Now I want to show you a great shot of a group of naked girls swimming in a pond!" As they looked at the picture in amazement I would add, "Uh, a train was passing at the time."

Now hear this: *Good pictures are worth good money.* Very good pictures are worth very good money, and the craftsman who can produce consistently good pictures should be able to earn a very substantial income. But don't forget, I said consistently good pictures.

Where do trick and experimental pictures come in? Certainly, some techniques in this category should be in the vernacular of every craftsman worth his salt. Many tricks

are so common that they are barely even considered trade secrets, while other, more complicated ones add immeasurably to a good photographer's vocabulary. We continue to add lenses, lights, and other appurtenances in order to expand our photographic services and/or keep up with competition, so why not trick and experimental techniques as well?

Most photographers use such simple devices as filters, diffusers, colored lights, double exposures, wide-angle distortions, panning, zooming, printing textures, grain, and increase or decrease of printing contrast. *These are all trick and experimental techniques!* Many photographers who use these procedures consistently insist that they are purists and that they never resort to "tricky" methods. If you offer your services for pay, then you should be able to offer any techniques required by your client. However, if you feel that there is a better way, by all means shoot it—after you have shot the scene the way your client requested it. Don't disregard the client's request and try to shove your own idea down his or her throat, or you may find yourself without an income. Those of you who wish to add to your reputation, name, or experience as a photographer will find creative techniques altogether useful, exciting, and profitable.

Many years ago a famous photographer gave me this sage advice: "Never sell a dollar print." What he meant was that we should always consider our efforts more important and valuable than the dollar print category—unless we are merely print suppliers. On the basis of this philosophy I have always endeavored to give more than my clients requested.

Nearly everyone doing advertising photography knows that when an art director makes the final choice of pictures, he will request two or three prints of varying contrasts, so that he may pick the one that is best for his purposes. However, besides giving an art director the choice of contrasts, I often include several other pictures if I feel that they are better choices. Sometimes I offer a variety of croppings, or perhaps bleach out the background, or add any embellishment that I think might make a more dynamic ad or make an art director's job easier. I approach each new assignment with the idea that, as a professional photographer with many years of experience, I have much to offer in the way of technical knowledge that the client most often does not understand. You must realize that usually a client will approve only of an approach or technique with which he is acquainted. For this reason, the client looks back at the firm's most successful ad, or its competitor's, and says, "That's what I want." Since the client's choice is based upon a limited knowledge of photographic techniques, the photographer must do the picture as the client requests. For personal satisfaction, however, I must also "do my own thing." Let me give you an example.

A few years ago a manufacturer of office furniture sent for me. He showed me a picture of a young lady posing stiffly at a desk; it was an ad he had run previously in a trade publication. I read the copy carefully; it said that the main feature of this particular office unit was the convenience of the design, which enabled the secretary to reach everything without jumping up from her desk. There was a list of some 20 innovations for her convenience that no other such unit had. I looked at the picture again; to me it said nothing. We agreed on a price and I took the assignment. A few days later I went back to the client and handed him six 8" x 10" transparencies, done very much like his old ad. He was very pleased with the job, particularly with a couple of shots where I had added a slight blue highlight to the stainless steel trim of the desk. After he had expressed his great pleasure with the job, I took out an envelope with one 8" x 10" transparency. It was a picture of the desk, with multiple exposures of the girl swinging around in her seat, opening and closing drawers, filing, typing, telephoning, and the like. He stared at the picture a long time,

After I had made a straight print of this picture, I quickly made these three exposures, changed the negative, and added the fourth. I felt that the repetition of the three, each growing in size, enhanced the fourth exposure, in which the model is smiling. However, I exposed so quickly that I failed to give the middle two pictures sufficient exposure. To make them come up, I applied hot water until I had a good color match.

then he jumped up and said, "That's what I've been trying to show for years." Needless to say he was a profitable client for many years, and the series of ads brought me a great deal of business. Still, when faced with similar circumstances, many of my colleagues will say, "Why complicate life; you're only making it harder for yourself." My answer is that it has never been my intention to be like any other photographer. Indeed, if we were all alike, there would be no need for this book.

Now that you have come this far, I must assume that you are serious about some aspect of photography and that you wish to add to your repertoire. In essence, your pride wants you to improve yourself and your techniques. Once you have reached this stage of development, I plead with you to take pride in every aspect of your craft.

- Work clean
- Be reliable
- Always try to do more than required
- Don't ever try to pass off second-rate work
- Don't take jobs you can't do well
- Strive for perfection
- Be honest with your customers
- Fill your customers' requirements first
- Show your client your version of the job
- Be an innovator
- Don't hesitate to throw in an extra print

One of my clients is the world's largest zipper manufacturer. An advertising agency booked me to shoot four color pictures for ads for this client. The job called for pictures of different members of a family, each involved with articles using the client's zippers. The four shots were: mother and young child; teen-age girl in her room; young boy in his room; and father alone. When booking each model for a one-hour shooting, I realized that if my booking schedule was done properly, I could get all of them together at one time and do a group shot. The client didn't request such a picture, so I shot it my way (did my own thing), using low key lighting. When the client saw the group shot, it was used for a full-page ad as well as for a poster on Railway Express trucks. So, besides the four original ads that were used and for which I was paid, I sold my own group shot picture for double use, making my day more profitable in satisfaction and money.

I may seem to be belaboring a point, but I'm trying to place trick and experimental photography more in the category of embellishment than as an end within itself. I don't think that there is any one technique that fits all subjects or every occasion. A few years ago a California photographer perfected the art of producing high-contrast litho film. He compiled a portfolio of beautiful prints, 20" x 24" dry-mounted, and headed for New York to make his fortune. By chance I happened to see his portfolio. The first picture was sensational, but the rest were meaningless, their subjects not fitting the techniques applied. After many months and much worn shoe leather he returned home, having made one small sale.

Let us, like great concert artists, go upon the stage and perform like masters. For our encore numbers we will show off our virtuosity with trick and experimental pictures, leaving our audiences with happy memories and the nice feeling that they got their money's worth and more.

1

EMBELLISHMENT

In order to take the first step in the direction of trick and experimental photography, I would like to suggest that you try embellishments, which often can upgrade your work. No matter what kind of photographer you are, there are many ways to add zip to your pictures.

Many pictures simply cry out for diffusion or textures or increased or decreased contrast. You must be the judge of what is needed, but this takes experience. Therefore, you must experiment until you feel that you have achieved the most out of your picture. When I have a set of pictures that has me particularly anxious, I make several sets of contacts that are underexposed, overexposed, and normal on soft, normal and hard paper. In this way I have found jewels among negatives that might otherwise have been merely average pictures.

PICTURE SHARPNESS AND DIFFUSION

Inherent in the business of photography is the photographer's pride in getting sharp pictures. The average amateur is often more concerned about the sharpness of his pictures than about the content, hence the mere idea of diffusion seems self-defeating to him. I wish to point out, however, that if a picture is already sharp, then slight diffusion will not destroy its sharpness, and it may save the picture. I have seen very few pictures of women that could not be improved with slight diffusion. No woman wants to see her pores and imperfections sharply defined. She will compliment you quicker if your portrait gives her an "Ivory Soap Complexion" than she will if it is needle-sharp. Diffusion decreases the contrast of your paper, so you may have to use a harder grade paper to achieve normal contrast.

Diffusion Devices

Although there are many kinds of diffusion devices on the market, there are two that I favor. One is a cross-star filter, which I use when shooting a particularly difficult subject or when trying to make very glamorous pictures. The second device that I use is a single layer of ladies' hose, stretched over a cardboard frame and stapled in place. I also have double-layer and quadruple-layer diffusers that I use on rare occasions. I diffuse slightly whenever I print people.

TEXTURES

Textures frequently enhance a picture by making it more pictorial. I find textures very useful when I have negatives with strong shadow areas; the textures add light, thus opening up the shadows and giving substance to the pictures.

At this juncture, let me make this warning: When using any unusual technique, use it with discretion. You can overdo. Suppose you went to a photographer for a por-

(Above right) If you have ever ridden in a New York City taxi, then you know how fast they go. To illustrate a speeding taxi I panned my camera, using a slow shutter speed to blur both the taxi and the background for this picture. (Right) I zoomed the guy on the motorcycle to give a feeling of action.

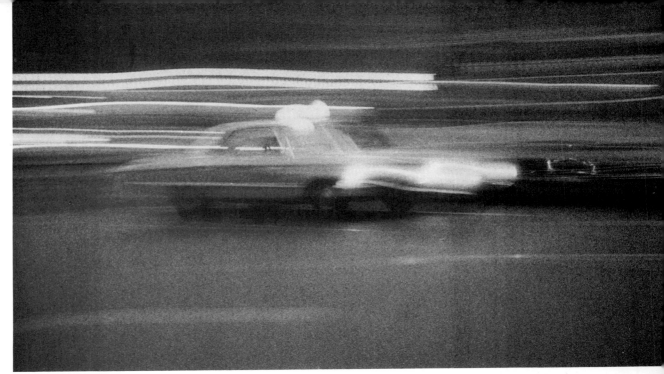

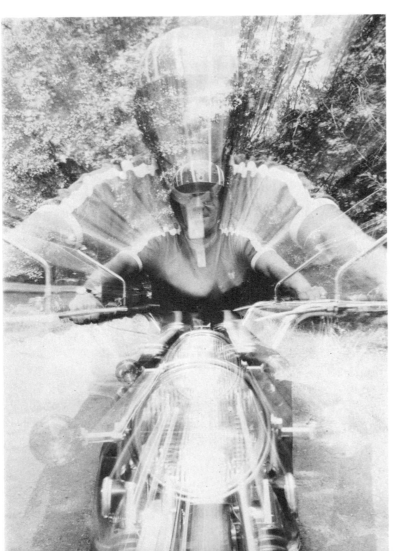

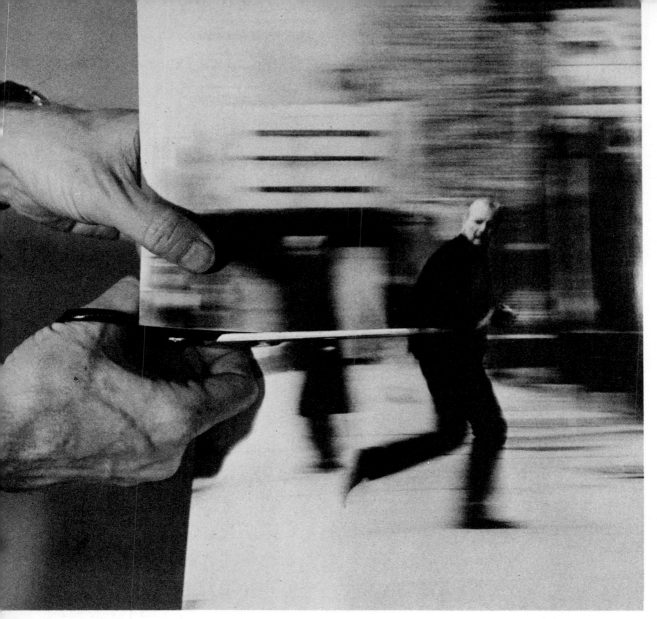

(Above) Another picture involving panning shows a man running in fear from a pair of scissors.

(Right) Zooming during exposure can do many things for you, depending on your application. In this picture of a young lady seated at a table, zooming added mystery to the picture without damaging the model's image.

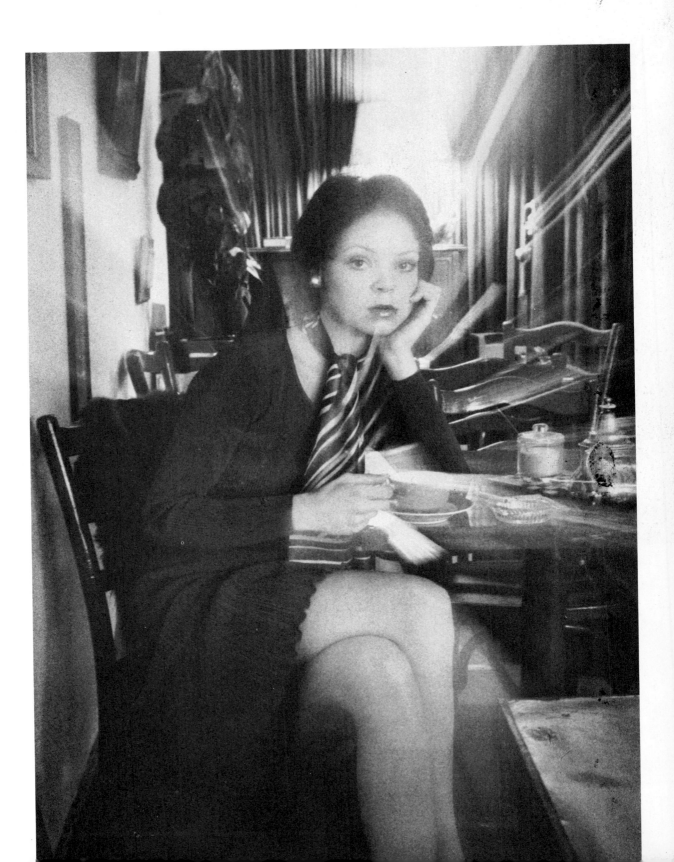

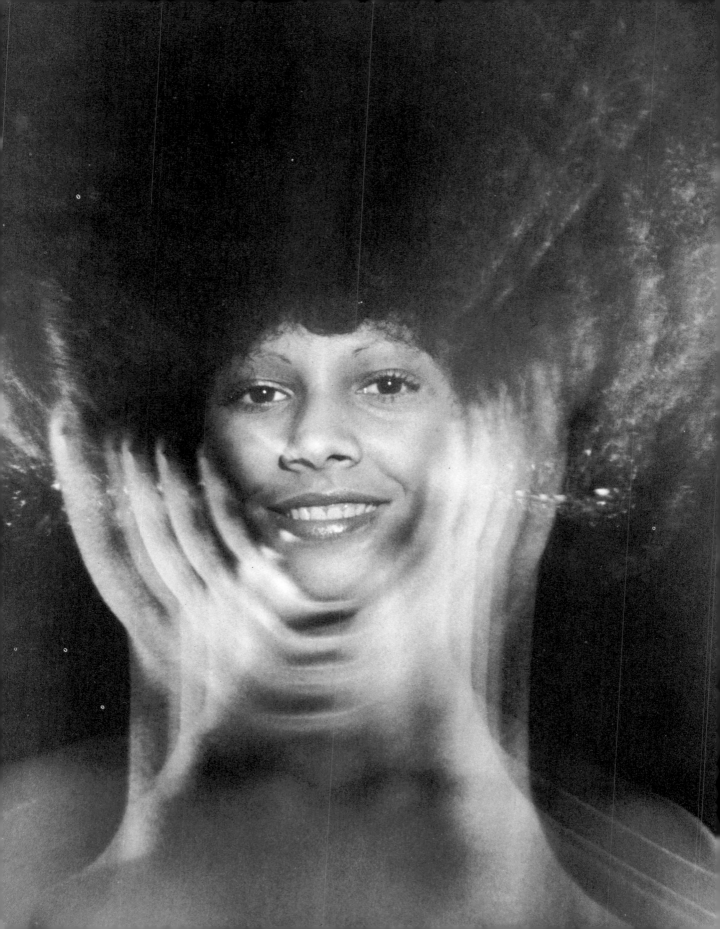

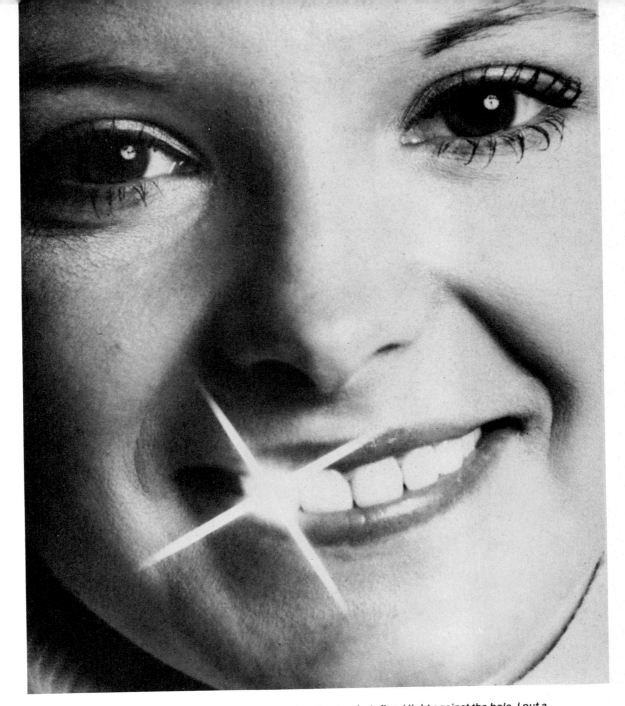

(Above) I made a tiny hole in a black paper background and put a photoflood light against the hole. I put a single cross-star in front of my camera and took several pictures for later use. Here I sandwiched a negative of a girl's teeth and a negative with the cross-star effect to get this print of shiny teeth. Once when I had to photograph some diamonds for an agency, I added stars using this technique. One can also add stars to eyes, to jewels, or to a night scene for Christmas pictures.

(Left) For the picture of this young lady I used a 43-86mm zoom lens on a 3× tele-extender. I flashed her image and then zoomed in steps while her face was sidelighted with rim lighting. Many exciting things can be done in this way if you take the time to experiment.

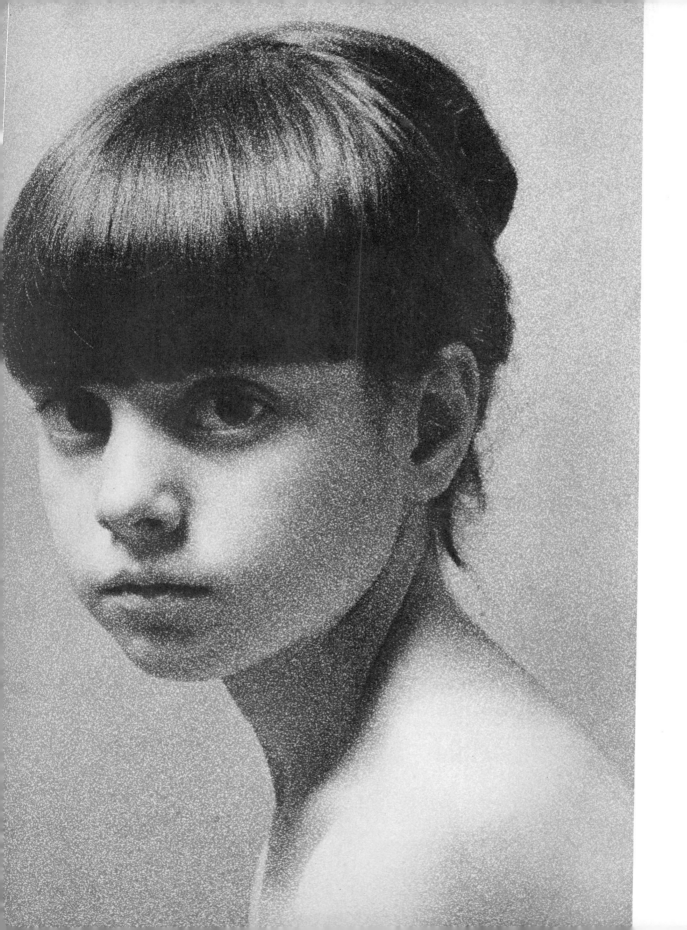

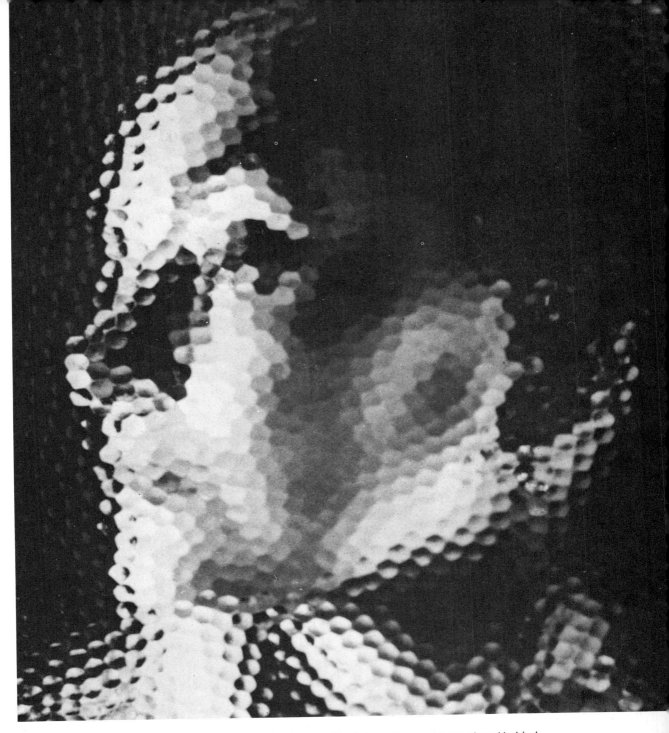

(Above) This picture was photographed through pebbled glass. The light on the model was placed behind the glass. I present this here to show what can be done with this kind of texture.

(Left) This photograph of my daughter, Leslie, was unflattering because of hard shadows around the eyes. Placing a Zipatone sheet over the paper and printing through the texture opened up the shadow areas and made a nice picture.

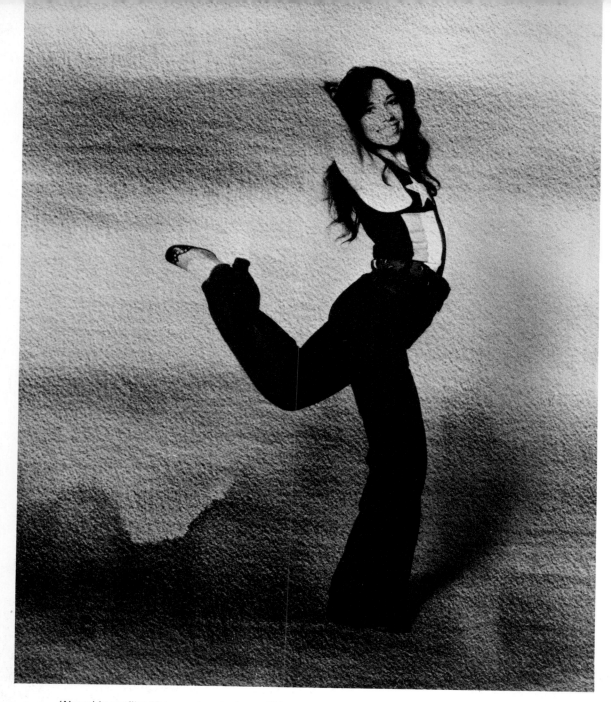

(Above) In my files I have various textures. This picture of my wife is a water color on rubbed paper.

(Right) I am always adding to my collection of textures, which I keep near my enlarger. I always try to get fairly thin negatives for texture so that I won't have to increase my exposure too much when I sandwich texture negatives with regular negatives. This particular texture was made with charcoal lines on white paper. Among my textures I have coins, canvas, sand, stones, grass, hair, fabrics, water, plaster, brush strokes, water color on rough paper, not to mention all the commercial textures that are available.

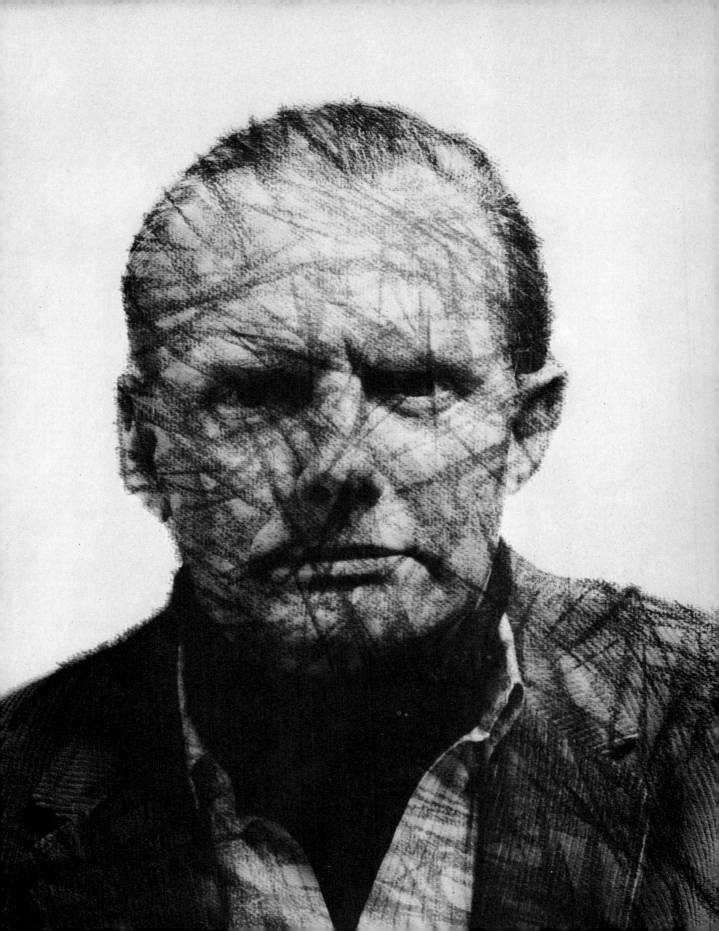

(Above) This picture was reproduced in a magazine. I made a copy on Repolith film and made this print. The texture of the printing, together with the lack of contrast in the film, eliminated much of the detail.

(Right) I did this picture of a gaucho model for a cigarette ad. One of the ads appeared in the rotogravure section of a newspaper. I thought the texture of the printing made the picture more interesting than the original, so I photographed the paper and made this print.

24

trait and he gave you prints, all of them with textures? In the first place, it would be boring to have all of your prints with textures. But if he gave you one masterpiece with a texture, you would feel it was a bonus instead of an imposition.

EXPLORING NEGATIVES

Every photographer who would like to be a master must learn to explore his negatives from corner to corner. Very few of us shoot haphazardly for no apparent reason, yet we peruse our contact prints at some time in the future and ask, "Why the hell did I ever shoot this?" Look closer, friend; hidden somewhere in your negative lies the answer. We have all been in a situation where we wanted to get something on film only to discover that we were without the proper film, lens, filters, or light meter, but we grabbed the shot anyway, on the spur of the moment. Many times it's a matter of having either a very bad exposure or no picture at all. I have always been of the school whose maxim is to "shoot first," then if you have time and the scene remains the same, you may concentrate on technical manipulations. Following is an illustration that I have used to test prospective darkroom men. Rarely have they been able to get more than 50 percent of what the negative offered.

Printing Problem Negatives

Now I will offer you a valuable secret for printing problem negatives. By using variable-contrast (VC) paper a little differently, you can obtain several contrasts in one print. For example, you shoot a portrait in front of a window that is backlighted, confusing your light reading, and get a negative of great contrast. Your model's head is thin, lacks contrast, and calls for a No. 4 or No. 5 contrast paper. At the same time your background is very dense and requires a long exposure on No. 1 paper, in order to bring out the design or frame for your por-

trait. Make test strips with the proper filter for the head and others for the background, then make notations of each exposure and filter. Now cut a small mask from the black paper that is used to wrap your enlarging paper, and place it over the filter in your filter holder under your enlarger lens. This mask should be shaped like a head, in order to dodge the model's head while printing the background. You are ready to print. Using the proper filter for the head, expose the entire negative. With the lens wide open, and viewing through the red filter, position your second filter for the background and cover the head-area of the print with the mask. Close down the lens and make your background exposure. You should have a well-balanced picture.

This "mixed-light" printing takes a lot of practice to perfect, but you will find it invaluable for trick and experimental pictures as well as for everyday printing. If you make a print with normal contrast where your highlights are just right but the print is lacking snap, use your most contrasty filter and make a second exposure that will add black to your shadow areas without affecting your highlights. This technique is almost essential for multiple printing as in the Aladdin's Lamp illustration.

FRAMING

I could go on about embellishments, as I feel strongly that a photographer must distinguish himself from others by adding the master's touch. I shall strike one final blow for the enhancement of your pictures: border frames. Even though there must be more than 12 million ways to frame pictures, most photographers print the same way most of the time—it is much easier. Many pictures need to be displayed on wide, white backgrounds in the same way that a diamond needs to be nestled in black velvet. Other pictures need ovals, circles, diamond shapes, hearts, and a variety of decorative borders. It would be impossible to shoot every picture within a horizontal

format; therefore, as we shoot, working fast, we automatically switch back and forth from horizontal to vertical without thinking that our subject dictates the way in which we shoot. By the same token, our pictures and subject matter dictate borders that will strengthen our composition, enclose or eliminate unwanted detail, or decorate or enhance an otherwise weak picture. Most art-supply stores sell mats of varying sizes and shapes, but interesting cutouts can be found in many merchandise packages, where the manufacturer wants to give you a peek through an interesting window. Smaller cutouts may be used in the filter tray under the enlarger lens or on top of the negative, while the larger ones may be placed directly on the printing paper.

Now that we have all magically become master photographers of eminence, we will always glean every drop from every negative, using the many procedures that we now have at our fingertips. We will give each picture thorough consideration and special treatment when needed, then we will package each in a suitable frame. And nevermore will we be guilty of producing second-rate pictures.

As we spur our steeds and pull down our sweaty, old Stetsons to shade our sensitive eyes against the sunset, we will ride out of an unruly past into the future, securely armed with knowledge and practice.

(Over) One twilight as I was sailing by the Statue of Liberty, my instinct told me to shoot a picture. The scene wasn't very interesting, so I held a cross-star in front of the lens in order to pull a ray of sunlight into the picture area. In my darkroom I exposed for detail in the statue, therefore the sky was overexposed. I was trying out a darkroom man, so I gave him the negative and asked him to make a good print for me. He gave me this light print, said it was the best he could do, and added that there was a streak in the negative anyway. Needless to say, I didn't hire him. The darker, dramatic print is the one I made.

(P. 29) Once when traveling through New Zealand, I took a trip before dawn through volcanic country. When the sun came up, the earth around me was smoking for as far as I could see, and the scene reminded me of the creation. It was quite an emotional experience, and naturally I took several shots. Unfortunately, the early morning light was extremely contrasty, so in order to expose for the foreground my sky was 25 times overexposed. I have used this negative to try out darkroom technicians, and this is the best print that they have given me because they failed to explore the negative's possibilities thoroughly.

(Below) This is the way I remember the scene. When I made this print, I exposed the foreground for 1 minute, then I tore a piece of black paper, covered the lower half of my negative, and exposed the sky an additional 25 minutes.

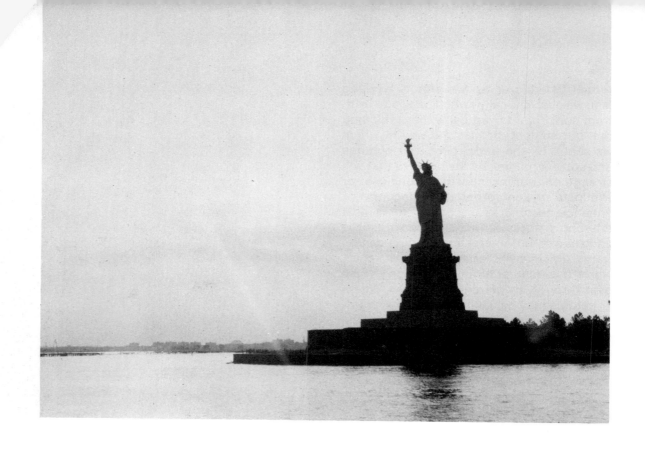

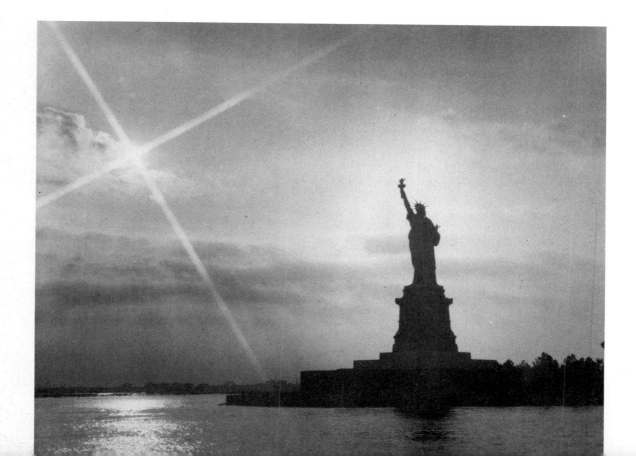

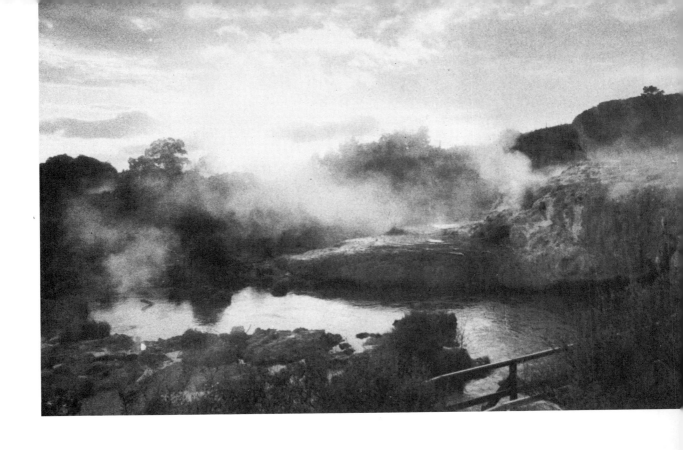

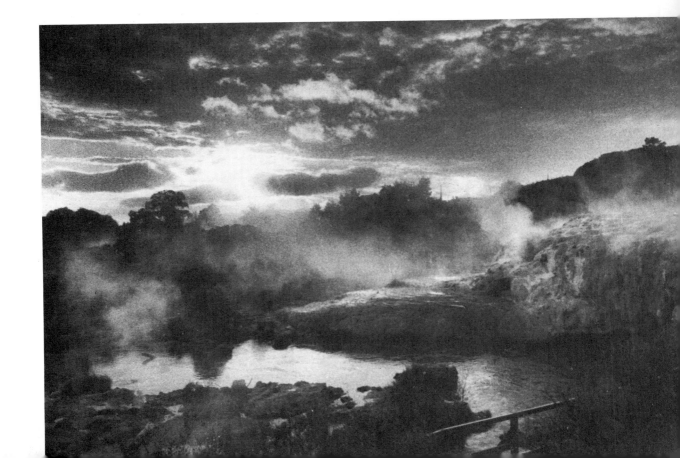

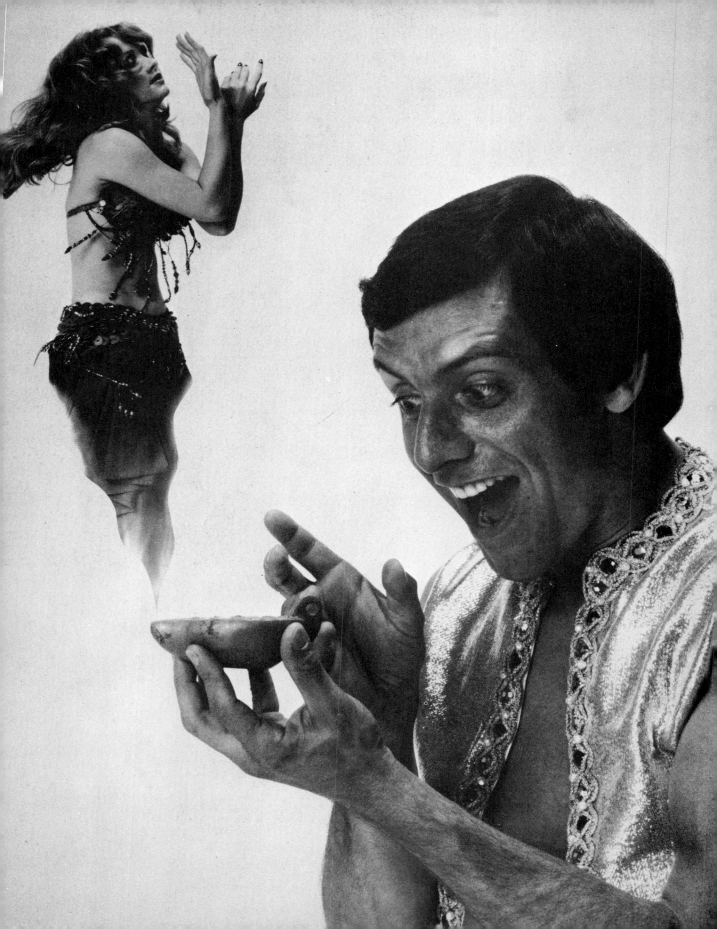

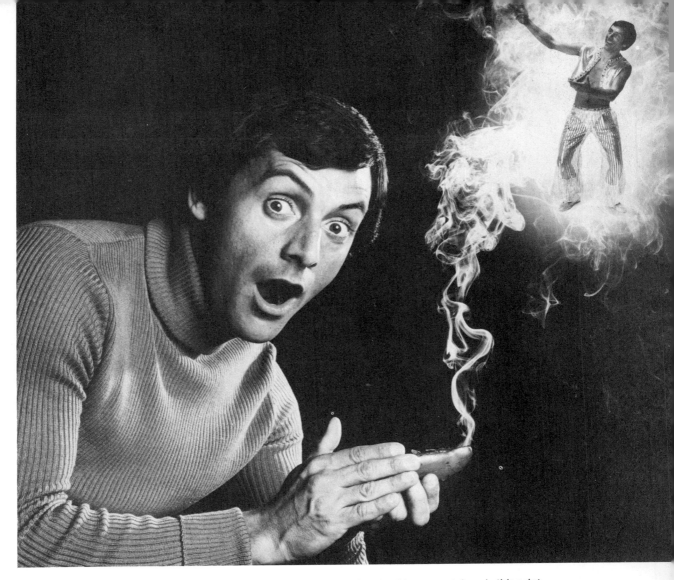

(Left) I decided that the genie should get a crack at the lamp to see what would come out. I made this print, leaving a white area above the lamp. I cut a large piece of flat, black paper to a point, and masking out the rest of the paper, I printed in the belly dancer. I dodged the bottom of the picture so that it would look like smoke. These were two negatives of different contrasts, so I used polycontrast paper with corresponding filters for each image. (Above) In order to do this picture of the model rubbing an Aladdin's Lamp, I taped a piece of rubber tubing to one side of the lamp and set it on fire. When I blew out the flame, the smoke curled up. I photographed the scene on a black background so that the smoke would show up well, and I used a small strobe to backlight the smoke. I had photographed the model in a genie costume on a white background. When I made the prints, I dodged an area in the smoke for positioning the genie, then I made the second print, placing the genie in the dodged area.

(Over) I shot this picture of my daughter, Leslie, on Kodak 2475 Recording Film in very dim light. The film was rated at ASA 4000 and developed in DK-50 for 9 minutes. Since the picture had strong blacks and whites, I decided to frame it with a double border. Therefore, after I made the print, I placed the border, which was ¼" wider than the exposed paper, on top of the paper, adjusted my easel another ⅛" all around, and the result was a white border as well as a black one. (P. 33) I made a print of soldiers on parade while holding a piece of cardboard on top of the paper for my border. Then I masked ⅛" all around the border and printed a soldier's head.

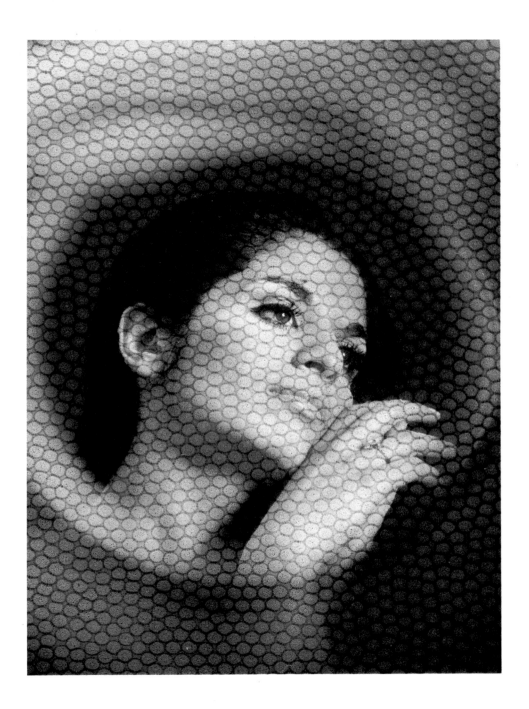

I photographed this girl through a clear plastic tube, which picked up color reflections on the inside. Later, I put the transparency in the enlarger, placed a texture screen of pebbled glass over it, and printed onto a sheet of 8″ × 10″ tungsten film. I diffused slightly during exposure to prevent contrast build-up.

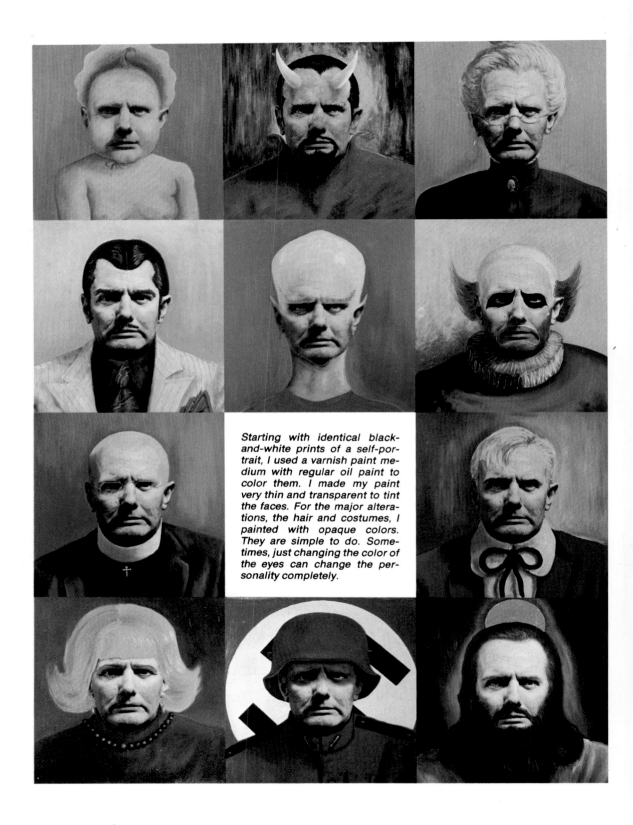

Starting with identical black-and-white prints of a self-portrait, I used a varnish paint medium with regular oil paint to color them. I made my paint very thin and transparent to tint the faces. For the major alterations, the hair and costumes, I painted with opaque colors. They are simple to do. Sometimes, just changing the color of the eyes can change the personality completely.

I shot two 8″ × 10″ transparencies in quick succession on tungsten and daylight films. When I processed the transparencies, one had warm tones while the other had a bluish cast. I cut the transparencies into triangles, then pieced them together so every other triangle was tungsten film. I outlined the joints with black tape and made a copy transparency on a green-textured, Zip-a-tone sheet.

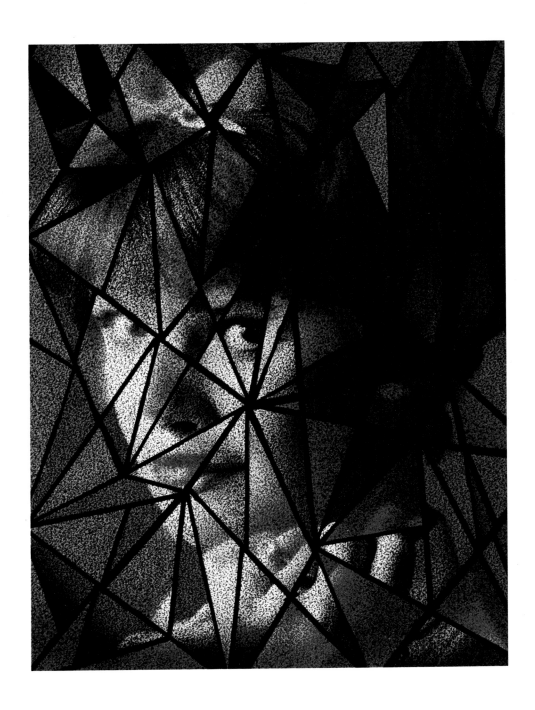

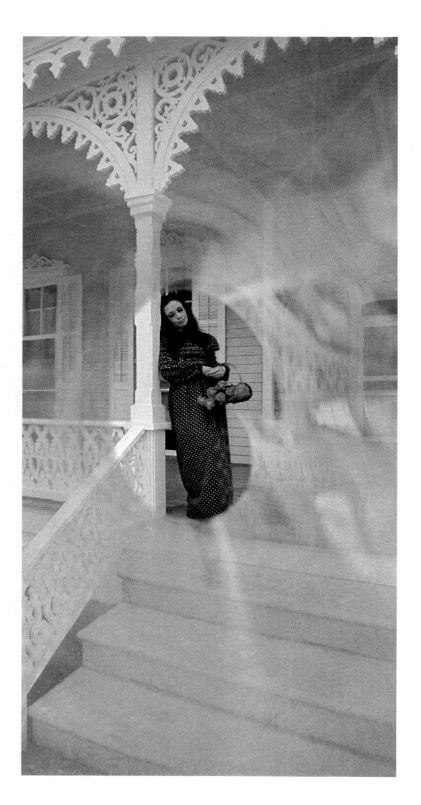

To isolate Marion and her bright colors, I shot this picture through a clear tube of cellophane.

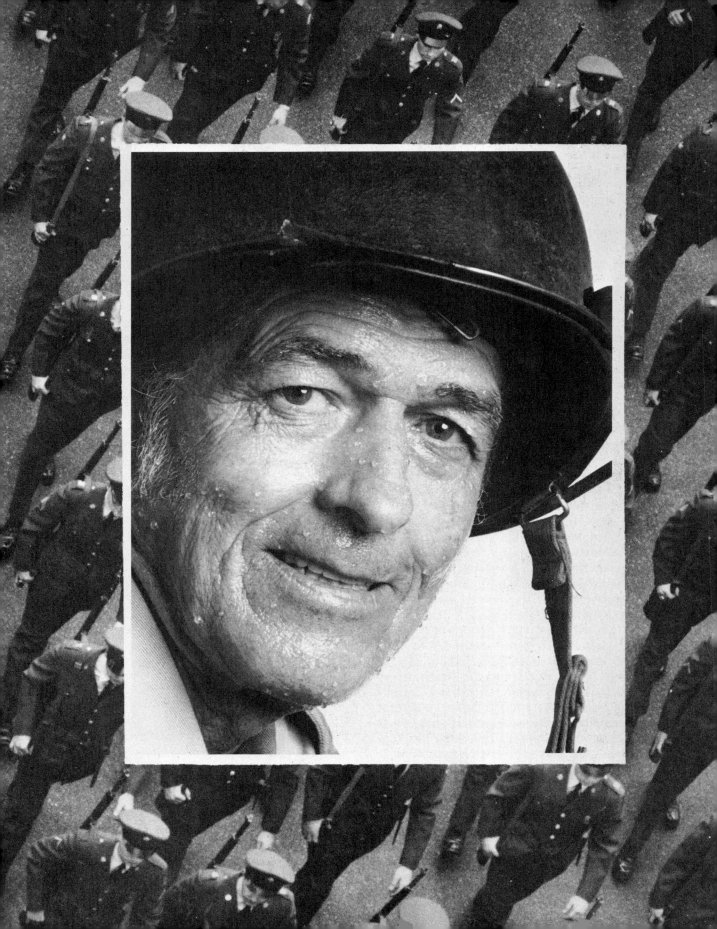

2

MULTIPLE IMAGES

When I was an apple-cheeked young lad, toting around my first Speed Graphic, a 4″ x 5″ monstrous camera, I accidentally superimposed one picture on top of another. The result was so fascinating that I have been doing versions of multiple exposures ever since.

Today multiple exposures are quite common in certain applications. Prior to starting this book, however, I did a great deal of research on the latest techniques. I discovered that very little had been done to give added dimensions to old techniques or to give the new experimenter a springboard that would bring new meaning to old ideas.

What do we mean by multiple images or multiple exposures? Why do it? What will the technique do for us? Knowing the answers to these questions can help us avoid waste. Moreover, finding the correct technique for the right picture is a very important step toward becoming a complete photographer.

The technique of multiple images enables us to get two or more exposures of the same person or thing in one picture; to show a variety of expressions; and also to show movement. Repeating a picture can fortify it and give it the rhythm of a drumbeat. Advertisers have learned that it is much more effective to repeat a slogan than to have a new, fantastic slogan every time. Multiple images can create symbolism. For example, the menacing head of a man against a city background could symbolize crime in the city. Here the two pictures superimposed are self-explanatory.

Many years ago a famous actress opened a New York townhouse. She wanted to decorate one room with either a picture or pictures of herself since she was, after all, selling her image. After our photo session, we found one picture that was so terrific, we decided to use it to do an entire wall, making a checkerboard of positive prints alternating with negative ones. The impact was gratifying.

Sometimes multiple images can make interesting patterns. I once did a catalog for a bird seed manufacturer. During the assignment I photographed a variety of exotic birds, including a very rare breed of canary. While experimenting in my darkroom, I made repeated prints of the canary, row after row, except for the center of the paper, where I printed a rooster. I showed the print to the client, just for fun. He bought it on the spot and used it for a full-page ad that read, "We are also making poultry feed."

To demonstrate in an ad that some fabrics will not fade, I once used multiple images that became progressively lighter and faded away. There are many applications for multiple images and serious exploration will be rewarding, whether you do it in the camera or in the darkroom.

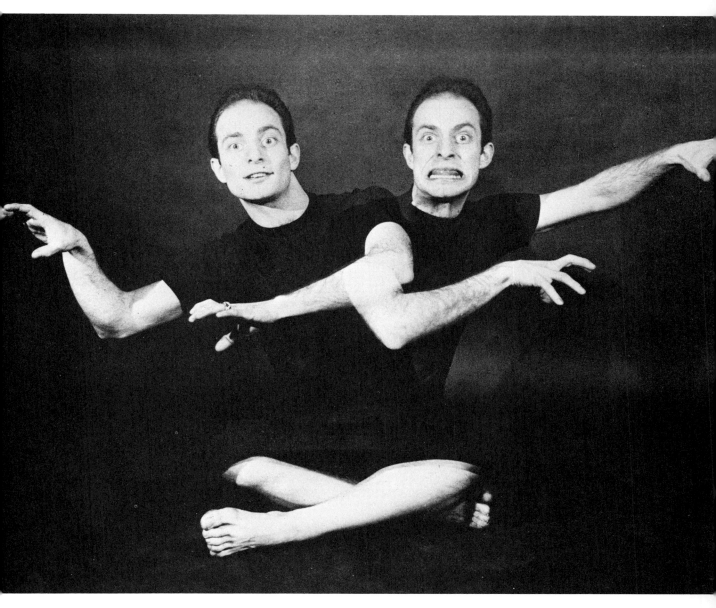

This double exposure shows how easy it is to illustrate a split personality.

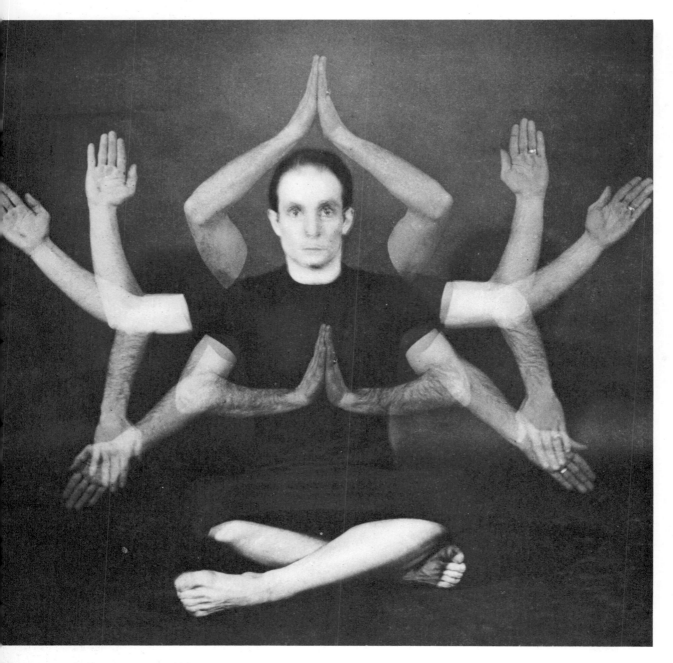

This dancer wanted his picture to look like the Indian goddess Kali, with many arms befitting anyone of the omnipotent persuasion. I might have done better had I put a black cloth over his head after the first exposure, but the result served the purpose at that time. Later I did a similar picture for a magazine. Since I was doing it in color, the procedure was more complicated, and it took me a whole day to balance and set up the lighting.

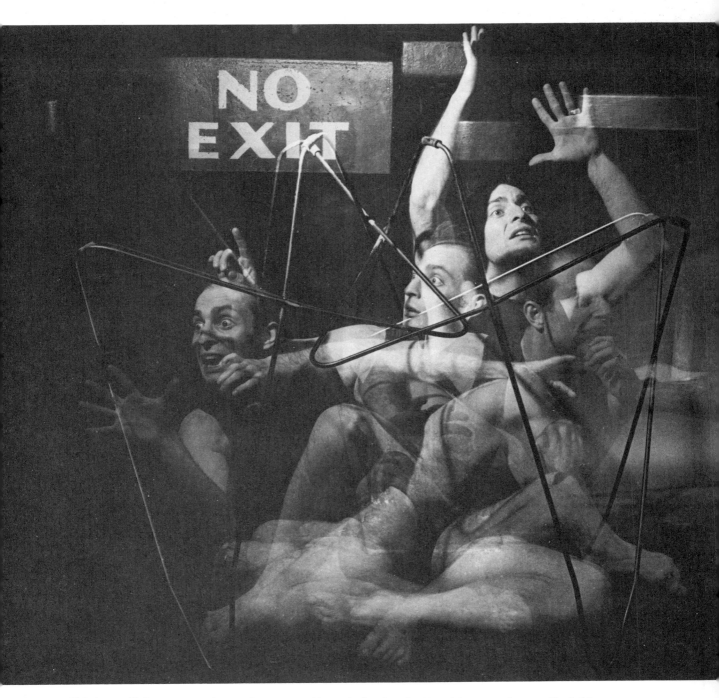

This is a multiple exposure of a man in a cage and is symbolic of one's attempt to escape from reality. I did not take care in the placement of the figures in order to give the impression of confusion. I sandwiched the negative with one of a ''No Exit'' sign.

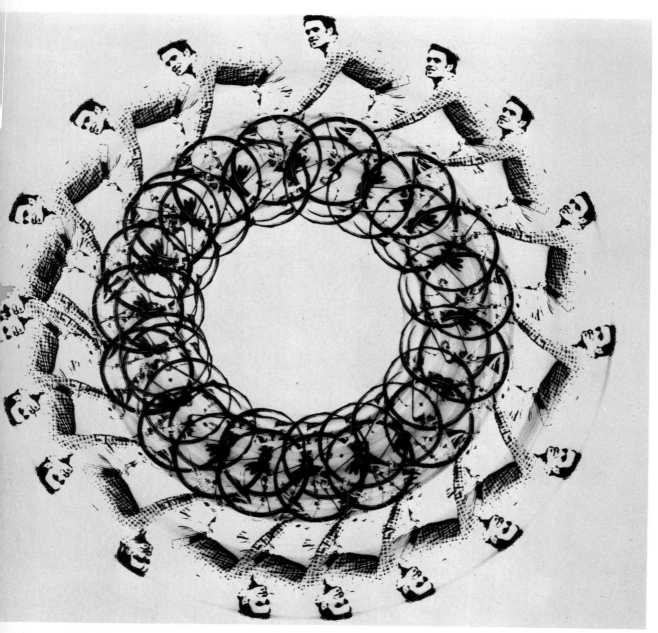

(Above) I made a Repolith of this bike rider. On the positive I scratched out all unwanted detail around the rider so that only he and the bike were visible. Then I made a Repolith negative from the altered positive (I had to use a little black ink and a needle to open up a couple of lines), laid a piece of paper on the enlarger, and stuck a pin in the center of the paper. I exposed, turned the paper, exposed, and turned the paper again, until I had made a bike racetrack. (Right) I wanted to make the picture of this dancer really jump. I made a straight print, then stuck a pin in the paper at the spot where her navel might be. I then slipped a piece of paper in my enlarger to cover the upper torso of the negative, and moved the paper to the right and to the left to make several exposures of the legs.

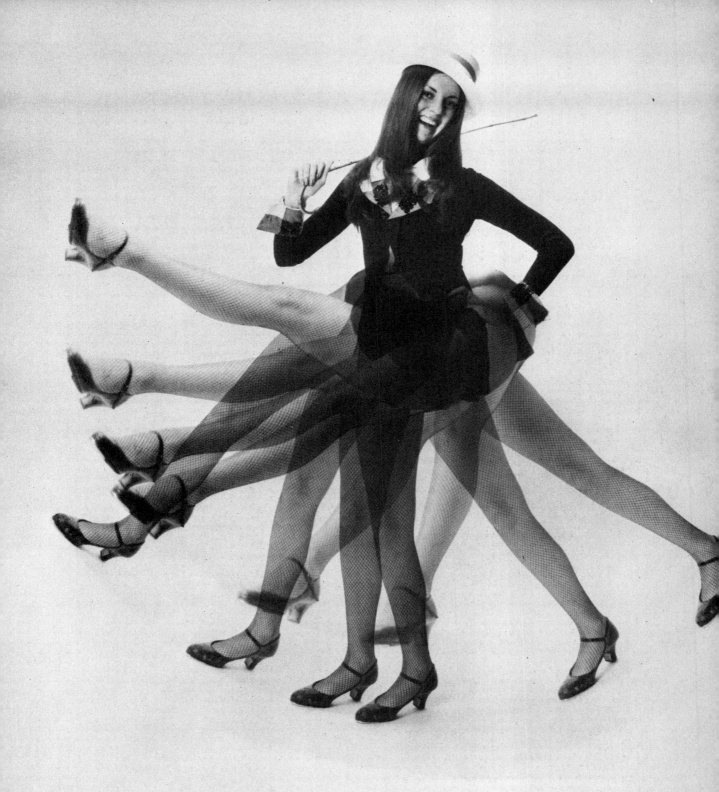

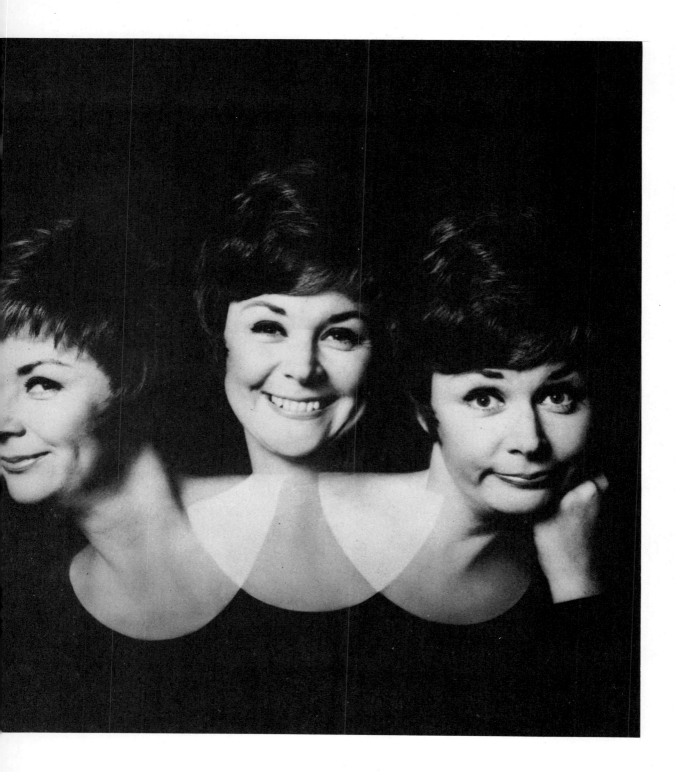

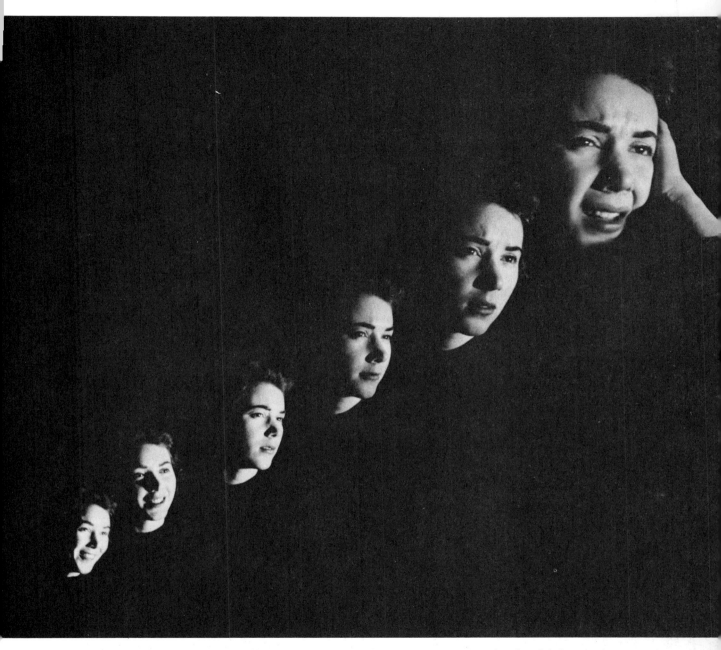

(Left) This triple exposure shows three facial expressions of an actress on one negative. Careful placement of the images is important. (Above) In a six-exposure picture like this, it is best to use a spotlight that will prevent too much light from falling on the background or the clothes. Marking your groundglass with a fine grease pencil is very important for the placement of the picture.

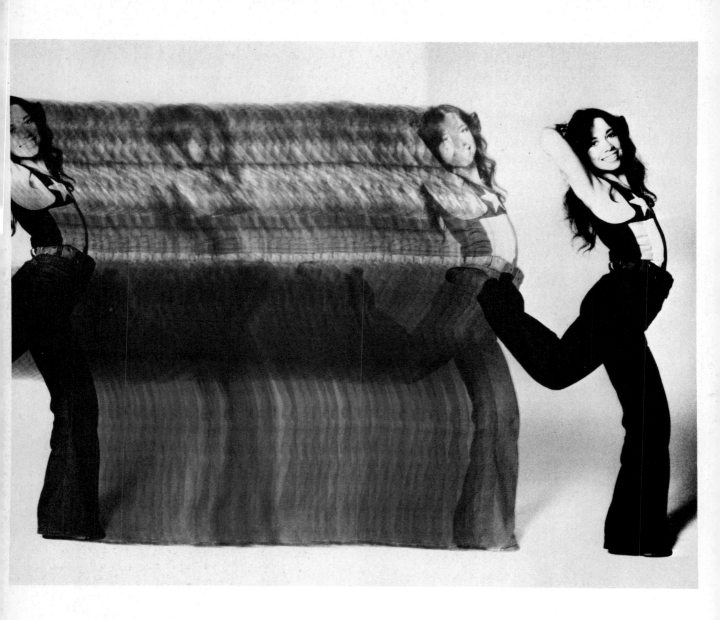

(Above) My wife looked like she was skating when I shot this picture, so I made a print on the left edge of the paper, turned on the light, and kept moving my easel in little jerks, hesitating here and there for more definition. I left room for one final exposure, which I made on the right edge of the paper. (Right) Here is a picture of that world-famous, millionaire photographer. I took an X-ray of my head and reversed it into a negative to print for the head. The eyes and glasses are the real me. I made this picture because most people don't like to be ridiculed, so I have to be my own clown.

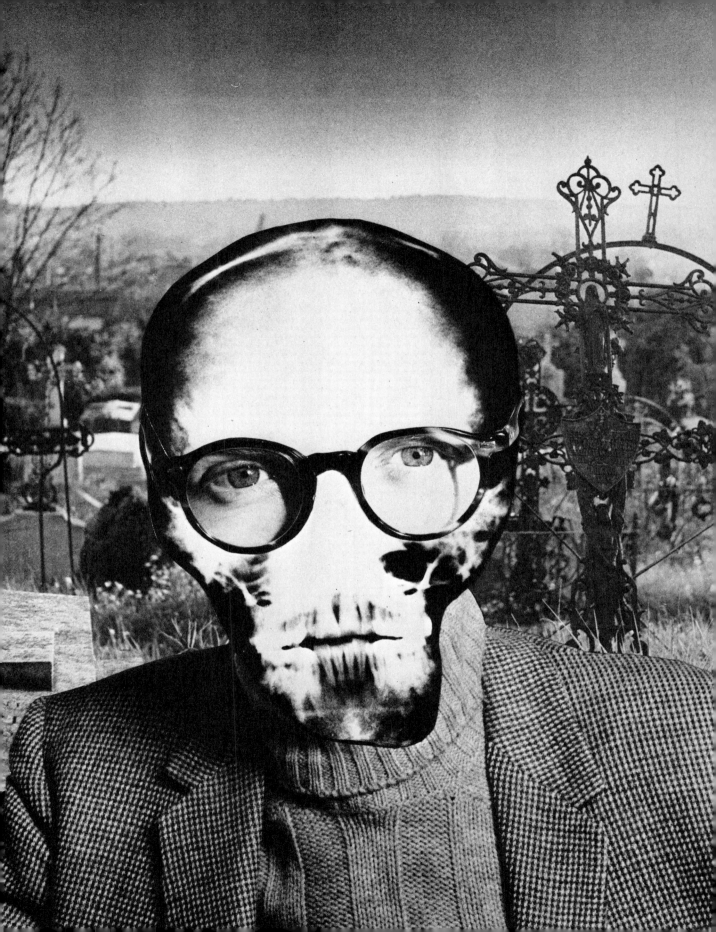

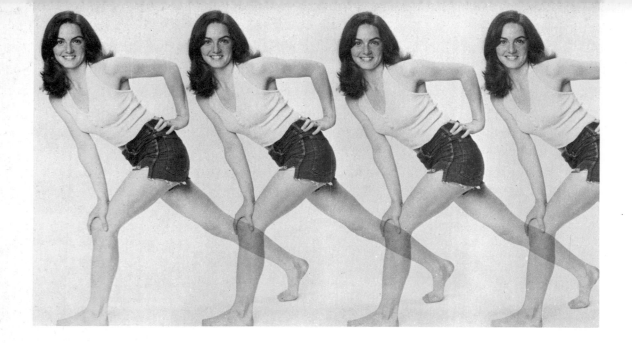

(Above) The girl in this picture had ordered several prints from me. When I put the negative in the enlarger, I didn't think it was too exciting. Therefore, I made a multiple print of four exposures by moving the easel after each exposure. I didn't measure my spacing. My client was a lot happier with four pictures of herself instead of one. (Below) When this entertainer ordered a print from me, I made this multiple-exposure print. He uses it as his business card.

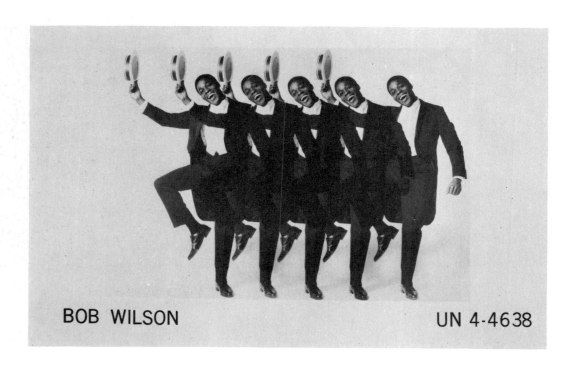

BOB WILSON UN 4-4638

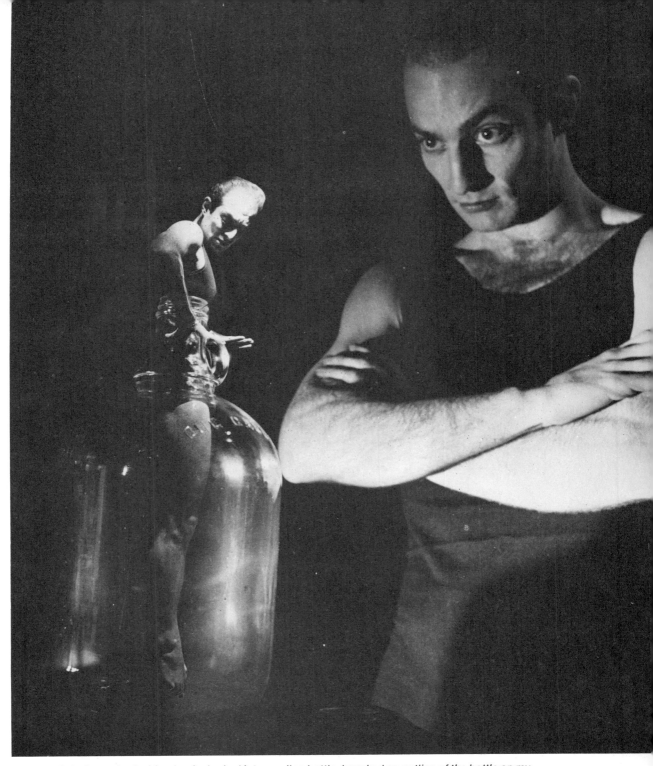

I photographed a friend as he looked into a gallon bottle. I marked an outline of the bottle on my groundglass, then turned my camera sideways and photographed him as he lay on his back on a black background. I aligned the picture so that he would appear to be stuck in the bottle, then made a second exposure. A little Spotone blended the figure and the bottle.

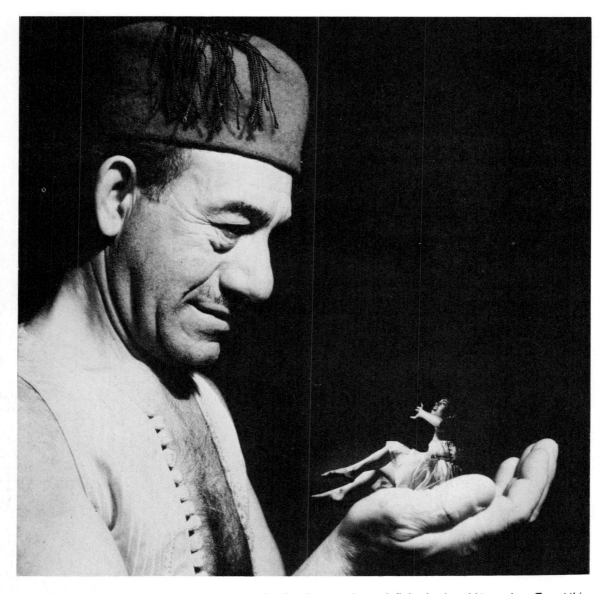

(Above) Multiple exposures can give the photographer an infinitesimal world to explore. To get this picture, I first photographed my father-in-law, Charlie, wearing an Arabian costume and holding out his hand and looking into it. I marked his position on the groundglass, then made a second exposure of a girl writhing on the floor on a black paper background. The final print showed the girl squirming in his hand.

(Right) This picture was shot at 1/8 sec. exposure while panning the camera. It was done initially to illustrate a man running in fear. Here I have added a bike rider running him down by making a multiple exposure of the bicycle.

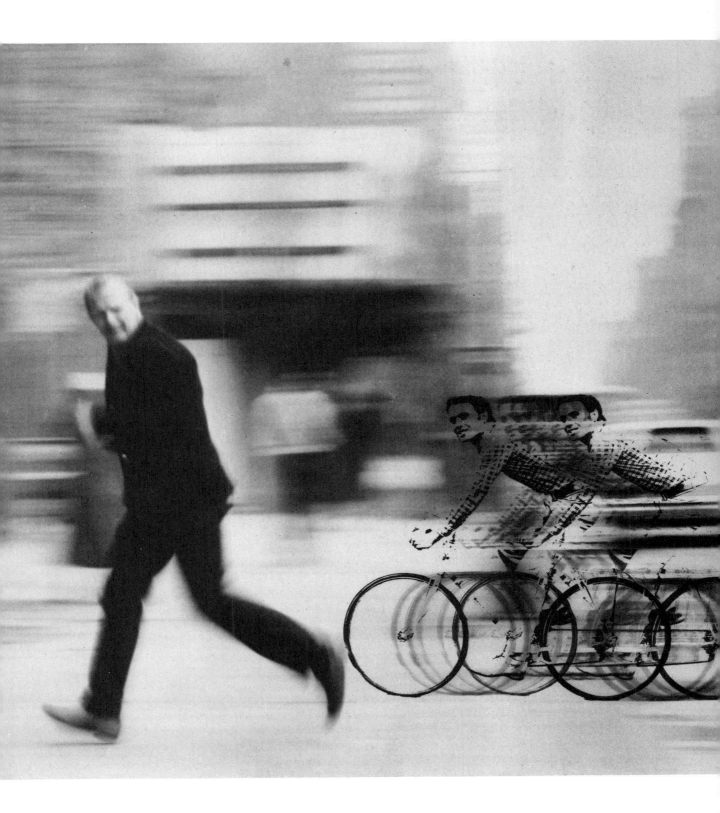

3

PRINTING-IN

It is my opinion that no photographer has really mastered this technique. However, this does not mean that such a person does not exist. I knew a darkroom man who was such a genius that he could print four or five negatives in one picture with perfect matching of backgrounds and without blotches. I regret to say that I don't have his finesse, but I haven't yet spent 50 years in a darkroom as he had. What's more, I don't intend to, either.

Printing-in is included here because I feel it is a fine tool for the many photo-artists of today. The big secret to this technique is to dodge or mask a certain area and later print an image in the unexposed area. If you are working with white backgrounds, you have fewer problems. If you are using subjects with black backgrounds, however, you must have an almost perfect blend of backgrounds or your print will be blotchy.

Suppose you have a picture of a group of people waiting for a bus and another picture of a nude, preferably on a white background. You want to make an eye-catching picture by putting the nude in the line. How do you achieve this? Of course, you can do a paste-up, if you want to reshoot it after cleaning up the edges, and if you can get the same quality print from a copy. Since we are talking about the technique of print-ins, however, there are several ways that you can get your eye-catching picture, some simple and some complicated.

To put the nude in the line, I take a flat piece of illustration board or cardboard and tape a flat piece of white opaque paper to the back, covering the board. I then focus the group negative on the board in order to get the correct placement and then make a test strip. Next I fasten this homemade easel to the enlarger baseboard. Once it is fas-

tened into place, I close the lid (the board taped with opaque paper), focus the negative on this paper, and with a pencil or pen, carefully outline the spot in the group picture where I want to insert the nude. Before removing the negative carrier, I make a note of the number on the enlarger scale.

(Here's a quick secret for simplifying this technique. Take your enlarger off the base and lay a yardstick along the track on the center post that carries the lens and enlarger head up and down. Carefully mark off inches, halves, quarters, and eighths. Next cut an arrow out of cardboard and glue it to the bottom of the enlarger head so that no matter how the enlarger is positioned, the arrow will always point to a number that may be used for reference. Then if you ever print a picture, say, at four seconds on No. 2 paper at $f/8$, and your enlarger scale reads $6^5/_8$, you can duplicate it exactly, anytime.)

Now back to the technique of printing-in. Replacing the group negative with that of the nude, I focus onto the sketch in order to get the correct proportion and spot where it may be squeezed into the line. Since the easel is now fastened securely to the baseboard, I insert the negative of the nude into a homemade, cardboard negative carrier, which I slide around until I get the nude in the right position. Then, very carefully, I trace an outline of the nude onto the covering opaque paper. I slide a piece of glass or Masonite under the covering paper, and with a very sharp, fine-pointed knife or razor blade, cut out the outline of the nude, either on or barely inside the traced line. I now take the cutout, place a narrow strip of double-sided tape on the back, and lay it aside temporarily. Next I make a test strip of the nude as I had done with the group scene when I focused it. I continue to make

test strips until I get one that matches exactly the tone of the group scene test strip. It is essential that all test strips be developed fully and timed exactly for a perfect match. When I finally have the correct exposure, I put enlarging paper into place on the easel, tape it into position, and fold the lid of opaque paper over the enlarging paper.

I can now view the negative of the nude (using the red filter) through the cutout on the covering opaque paper. If the surface is not flat enough, I cover the entire thing with a piece of clean picture glass. I now make an exposure of the nude through the cutout. At the end of the exposure I lay the cutout of the nude, which I had put aside temporarily, into the cutout hole on the opaque paper. Returning the original group scene negative to the enlarger carrier and setting the enlarger to the correct scale number, I refocus through the red filter. After turning the enlarger lens to the correct f/stop, I carefully lift the lid covering the enlarging paper, leaving it clear except for the cutout of the nude, which I put into the proper position with double-sided tape. I then make the correct exposure for the scene. After the exposure I gently remove the cutout and develop the print. If my judgement was good and my workmanship careful, the final picture will look absolutely authentic, needing, perhaps, only a touch or so of Spotone to tie together loose ends.

(Pp 50-52)
Here I made a dodger in the shape of the man's face and dodged during the exposure. I removed the exposed paper and put in a blank sheet of paper, on which I had drawn an outline for the placement of the baby's face. I put the baby negative in the enlarger and lined up the baby's face with the sketch. I had made test strips for both negatives, so I exposed the baby's face, through a hold I made with my hands, onto the paper that I had used to expose the man's head.

We call this picture "ostricat." Here a model placed her head face down on the paper while I exposed it. I then vignetted the cat's face in the center of the white area.

This picture was done by using the same method as in the ostricat picture. In this picture, however, I mussed up my hair, lay my head on the easel, and stepped on the foot switch to expose the paper. I then added this unlikely face.

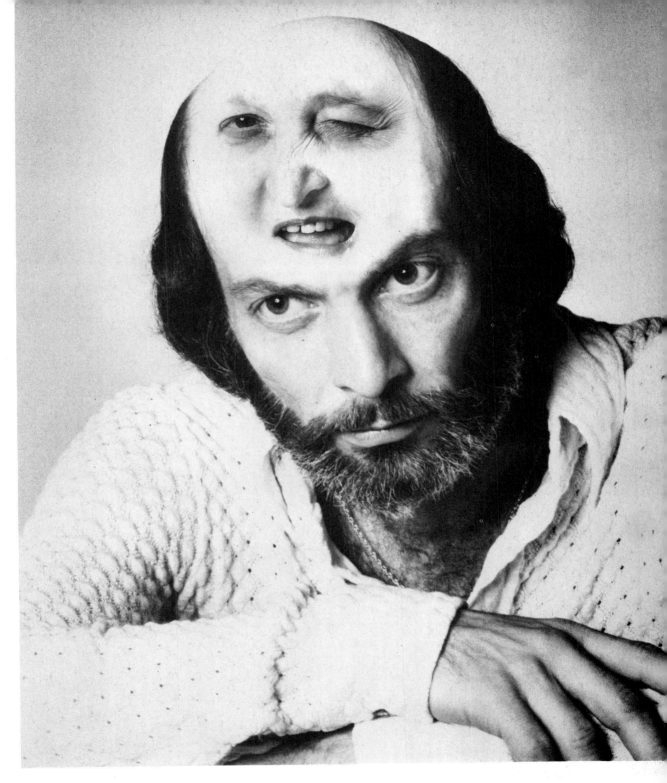

A bald head always gives me an idea for putting something absurd on it, particularly if my subject has a sense of humor as my friend in this picture, I printed-in this face, then bleached out most of the skin tones to make the picture more ghostly. Not only can you print things on bald heads, but with a little body paint you can add words like "X-rated," "Empty," "Kiss me," and the like.

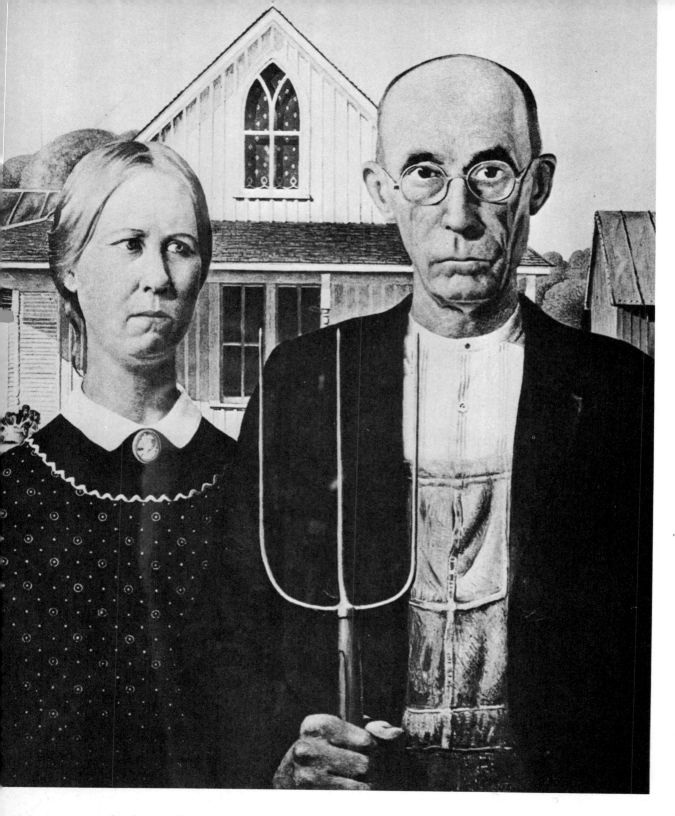

I took some silly pictures of my wife, Marion, and me, put them on a print of a painting by Grant Wood titled "An American Gothic," then rephotographed it. We made some greeting cards with the picture.

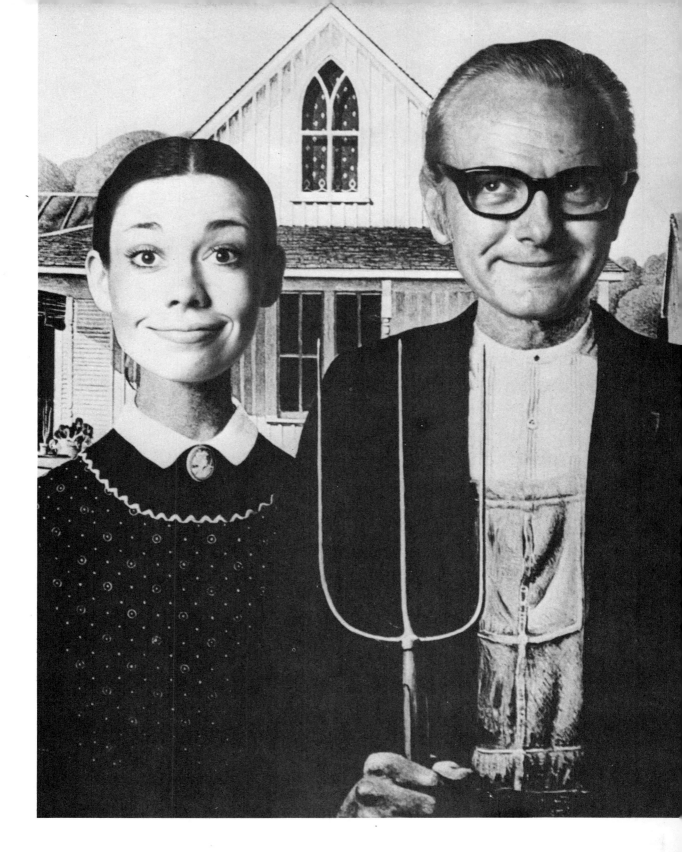

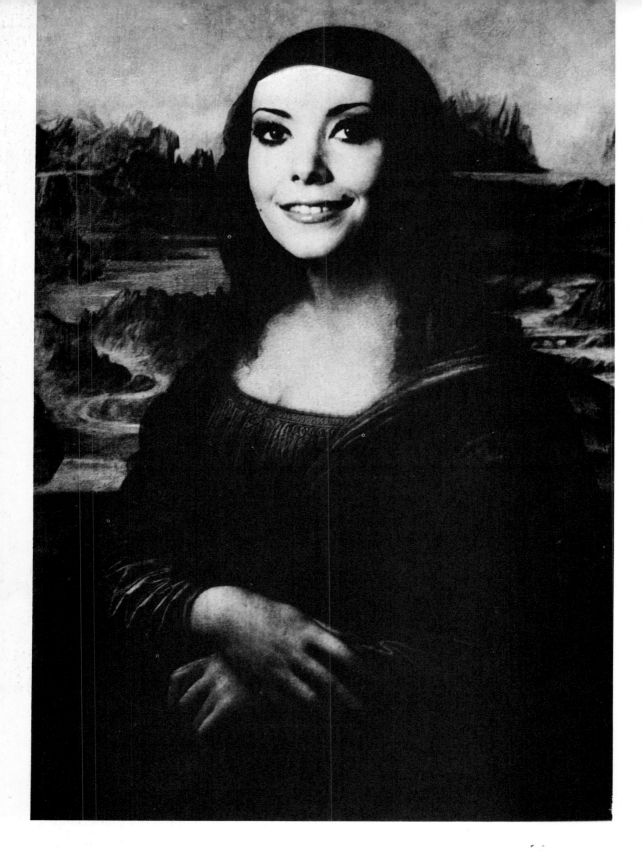

58

(Left) I keep photographs of many famous paintings in my files, including one of the "Mona Lisa," which I use for printing-in the faces of other people. Here I put the face of my sister-in-law, whose name happens to be Lisa. I pasted up her face on a print of the Mona Lisa, touched it up with Spotone, and then rephotographed it. I tinted her copy of the picture to look like the original painting. (Above) I replaced the faces of the ladies in this painting with those of my wife, mother-in-law, and sister-in-law. I made a large sepia print, which I tinted and framed for my mother-in-law.

I photographed this ink drawing for my files. On occasion I cut out someone's head from a print and insert the head on one of the cartoons to make a greeting card for that person. This falls into the same category as my wanted posters, and so forth.

4

THE EYE

One day a photography critic came to my studio to look over some of my photographs for a magazine article that he was doing about me. One of the pictures he perused was a 20″ x 24″ print that I particularly liked. He kept coming back to this print, even though many of the others had more exciting subject matter. In the end he selected my favorite print and said, "Definitely this one, because it has such great color!" They were all black-and-white prints, but I understood exactly what he meant. Do you?

Inherent in the business of visualization is a fine line between tone and color, mood and color, and composition and color. Writers and musicians refer constantly to the coloring of a passage, an aria, a character, or a performance. Understanding the feeling that makes one see color in a black-and-white print can make the difference between a good printer and a master printer.

Shooting pictures in color does not always give you the kind of color I refer to. The best way to explain the phenomenon is by pointing out that the practiced eye feels rather than sees color, while the inexperienced eye is blinded by color and cannot faithfully analyze the picture beneath.

COLOR DEVELOPERS FOR BLACK-AND-WHITE

Obtaining color from black-and-white is readily available to anyone who wants to put a little effort into making "a mountain out of a molehill." There have been color developers on the market for as long as I can remember. These are packaged in small boxes and are simple to use. Basically, color developers are manufactured so that you may print your black-and-white paper in colors of blue-and-white, green-and-white, red-and-white, and so on. Manufacturers of these developers recommend that you double your exposure for a normal black-and-white print. If you find that blue-and-white is too pale, you can give your paper a quick dip in a black-and-white developer and add either a little or a lot of black to your print. You may also mix your color developers until you get the tone you desire. For example, if you mix blue and green, you will get a blue-green developer; red and yellow will give you an orange developer, and so forth. Make a gang of small prints and try the Simple-Simon procedure above.

Now brothers and sisters, step into my darkroom and we will sort out the men and women from the boys and girls. First we take 10 or 12 empty, instant-coffee jars and mix all our color developers. If we have five colors, after mixing we now have five jars of color developers. We pour a little from two or three jars into each of the empties, producing many nice blends of colors. If our five original color developers are red, yellow, blue, green, and sepia, after mixing we can add orange, purple, yellow-green, blue-green, and brick-red to our list. We also can add black to any of the colors.

Our palette is prepared, and we are about to make a picture, the likes of which no one has ever seen. Having selected a negative with exciting subject matter and good tonal range, we make a good quality black-and-white print (the same size as the color print we want). After the print is thoroughly developed and fixed, we wash it. Next we double our exposure, make a test strip, and develop it in the color developer, also adding a little black in one area. If our test strip has the quality we want, we are ready to

(Left) I did this illustration for a magazine that wanted to show man's loneliness amid the debris of a city. I placed my glasses in the debris and focused the man through one lens. You may shoot through bottles, reflections in water, or window reflections. (Below) I was in a rural area not too long ago and was amazed to find mud roads and a one-horse shay. Putting the scene on Kodalith film added more bleakness and antique quality befitting the subject.

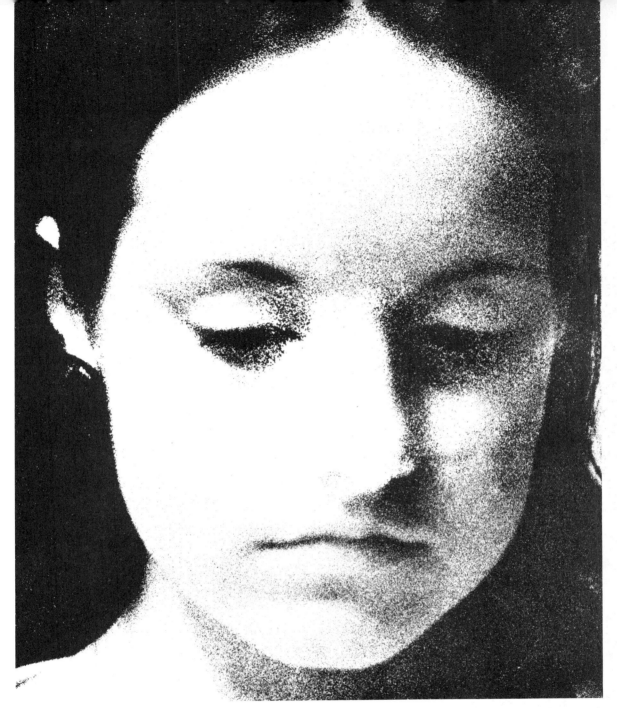

I photographed my daughter, Leslie, on Kodak 2475 film because of its speed and grain. Then I enlarged on 8″ × 10″ Repolith film, first making a positive film from which I printed a negative print. Then I made a negative film by contacting the positive with another piece of Repolith film. With my negative I got a positive print. I sandwiched both the negative and positive films together, but slightly off-register, and got the bas-relief effect shown on Pp 63–65. The third picture in the sequence looks like a medieval statue.

➡

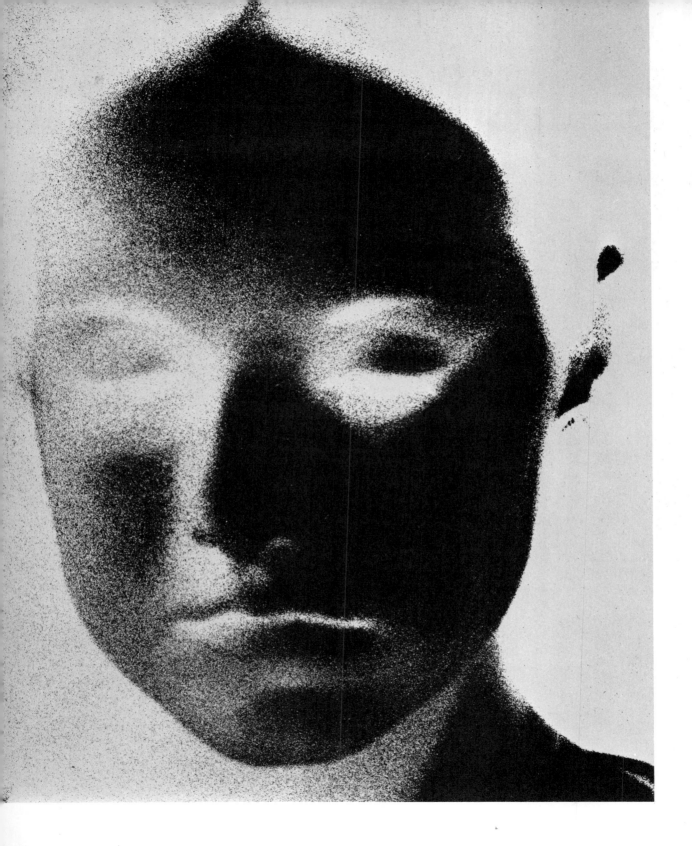

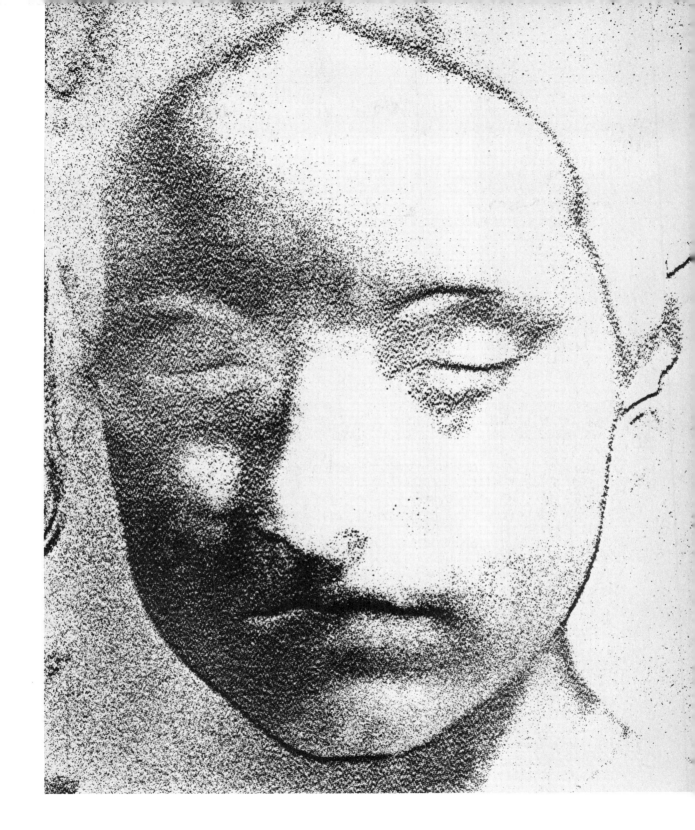

make our masterpiece. But first we remove our black-and-white print from the wash water and hang it up behind the darkroom sink, for two reasons: One, we need a visual guide to see where to apply a particular developer. Two, we must study the print to determine which areas we want to color red, yellow, or blue.

In our sink we should now have: the open bottles of color developers; several soft brushes; cotton swabs and balls; clean, cut-up sponges; two paper cups containing a weak and a strong solution of bleach; a wash tray filled with clean water; hypo; stop-bath (or water); and a clean tray or board, larger than the size of our print and turned upside-down, because we are going to apply developers to small areas at a time. The tray or board should be as level as possible so that the solution won't run. If we still have space, we include a tray of black-and-white developer; if there is no more space, we keep a jar of black-and-white developer nearby.

I see that you are growing impatient, so let's get going. We remove a sheet of enlarging paper from a box (by safelight, naturally). We gently make a mark on the back of the sheet to indicate the top of the picture and make our exposure. We repeat the same procedure with a second sheet of paper. We return one sheet to the box and put the other to soak in water. At this point we even turn off the safelight. When the paper is soft and pliable, we hang it up to drain off excess water. Finally, when we have a wet print that does not have any water on its surface, we turn on the safelight and lay the print down according to the mark we made on the back. Keeping an eye on the black-and-white print that we hung behind the sink, we begin *rapidly* applying color developers with the appropriate applicators to the areas we chose. At this point it is not necessary to select naturalistic colors, so we can make our skies green and the grass blue if it suits us. We should, however, be cautious about getting one color into another. When developing is nearly complete, we can let the colors blend together. The fact that our paper was wet in the beginning made the developers bleed nicely without leaving harsh lines.

We have now been working on the picture for three or four minutes, the full picture is nearly developed, and we find it quite pleasing, although it could use a little more snap. So we dip a tuft of cotton into the black-and-white developer and apply it to areas that need accenting. WOW, our picture is beginning to sing. Now we work very fast, because we don't want any overdevelopment or staining of our print. A quick wash, then into the hypo. We turn on the light to the tumultuous applause and cheers of our colleagues, but we must plead with them not to carry us on their shoulders and into the streets, for we still have one exposed sheet resting in the box.

Slowly, a hush falls over the darkroom as we extinguish the light and remove our second exposed sheet. This time we work with greater certainty, having just gone through the ordeal. This time, however, we DO NOT wet the paper first, but start applying developers directly. We are using a different color arrangement this time, because the first print was a success. Instead of duplicating it we want a different print if possible. Fired with our first triumph we are much more daring, and the colors are flying, right and left, blending on the paper and running together. We use water here to weaken the tone, or wipe the paper to pick up excess, or make a puddle of developer where we want strong color. This print is coming up wilder and more brilliant than the first one. Quickly, we dip the whole print into black-and-white developer and drain it over the tray while we watch the tones. Then we submerge the print in hypo. As soon as we are able to turn on the light we study the print briefly, add weak bleach here and there for contrast, drain the print, lay it on the back of the tray, and cover it with several sheets of paper towel to dry the surface.

Holding the print flat we now take a fine-pointed brush, dip it in the strong bleach, and make our highlight a startling white. Another masterpiece! We turn to take another bow from our audience but find that we are alone in our darkroom—the loneliest place in town.

What can we do for an encore? Men and women, we haven't yet scratched the surface.

PRINT TONERS

Print toners, which come in a variety of colors, may be used in a similar manner as color developers. However, print toners change the color of your black-and-white print after it is printed. You can take a handful of prints from your files and use these to experiment on. If you have a print of a blonde girl in your files, you can make an eye-catching picture if you tone the hair yellow and the eyes blue, and leave the rest alone. I once had a picture of a group of people with a very handsome black man in the center. I toned his skin sepia. This literally made the picture jump right up at you.

COLOR PAPERS

Can we still get more color from black-and-white? Yes, indeed. How can I count the ways? Let's find out what's available in the kindergarten. What's that? Colored enlarging paper? Oh, I'm so bored with straight prints on bright papers. How about mixing the colors by making a paste-up, re-photographing the paste-up on color film, and adding color gels for variety? I keep eight different colors of paper in stock. If I make eight prints, using each color, I can cut them up in myriad ways to make jigsaw pictures and abstracts, and I can make each object in the picture a different color. I can also add different colored objects to a black-and-white print.

Example: I once attended a concert and happened to take along a camera loaded with black-and-white film. One of the concert managers came over and said that if I could get a good shot of the performer, he would use it for an album cover. He rushed away before I could tell him that I only had black-and-white film in my camera. Oh, well, I figured that one good black-and-white picture was better than no picture at all. I managed to get one good shot of the performer, right in the center of the negative.

Back in my darkroom I tried a print on color paper. It was nice but unexciting, so I tried another color, and another, until I had printed on all eight colors of paper. None of the eight prints really pleased me. As they lay before me I realized that by placing them in a certain order, seven of the colors harmonized nicely. Using a compass I cut out the performer's head, then using the same center point I cut a larger circle on the next color of paper. I repeated this process until I had made seven concentric circles of increasing dimensions. Then I mounted them carefully on an old phonograph record, placed the record on a piece of midnight-blue velvet, and shot it on color film. I was very happy with the results until I learned that a neighbor had recently acquired a magnificent antique Victrola. I removed its center post so that I wouldn't punch a hole through my photograph, placed the record on the turntable, and placed the needle on the first groove. I re-photographed the scene in color from several angles. DYNAMITE! The record company bought the picture that I had shot using the blue velvet background, and I shed a bitter tear. What I failed to realize was that the Victrola had been manufactured by a competitive company.

COLOR SKETCHES

Let me tell you about another color technique that will make you throw up your hands in despair and say, "Hell, I can't do that." (I'll yell back, "Oh, yes you can; it

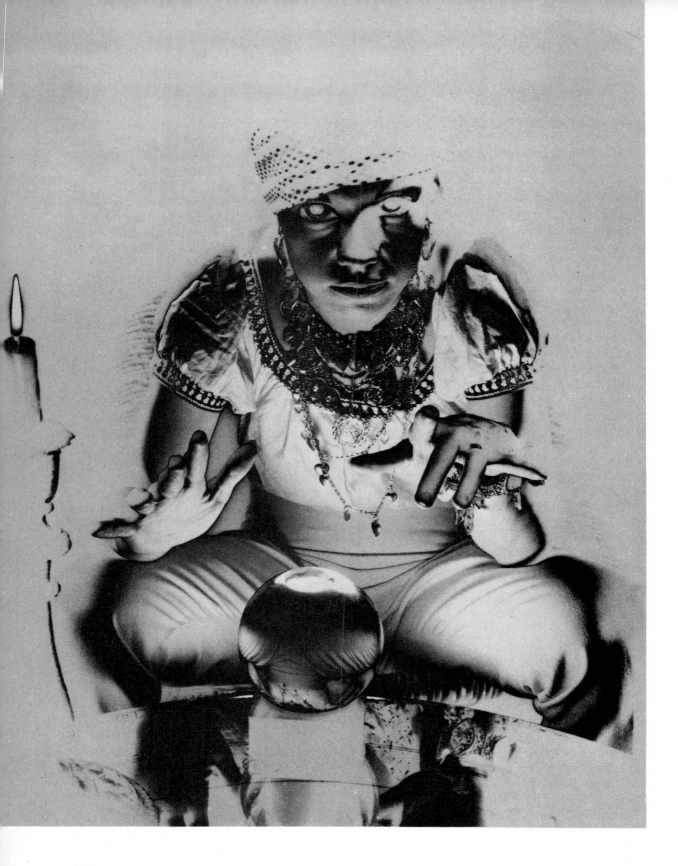

only looks complicated, and any mistakes you make won't hurt a thing.")

Again we select a negative with good tonal range, nice contrasts, and interesting subject matter and place it in our enlarger. We have on hand either stretched canvas, Masonite painted white, a piece of white enlarging paper that has been fixed, or any board that will not fall apart or buckle when placed in solution. We put whatever surface we have selected for our print on our enlarger baseboard and focus our negative. When we have placed our surface exactly where we wish to make our final print, we must attach a guide to the baseboard, which will help us relocate our board or canvas in exactly the same spot, time after time.

When our guides are firmly secured, we take a fine dry-marker, charcoal pencil, or a hard pencil (soft lead pencils eat through paint) and trace the outlines of all the images in our negative (this should be done with the lens wide open). Now we take our sketch and paint all the images with color. (I usually use acrylic paints because they dry fast, are bright, and are completely impervious to solutions. Black printing tones down your colors considerably.) If we want to block out areas, we may use spray paints, stains, or dyes that are not water-soluble. It does not matter how we apply the color. We must keep the color pretty smooth, however, because too much texture may cause problems later.

When our paint dries thoroughly, we moisten the front of our painting. If water

stands on it in beads, then we must coat the canvas or board with the primer that is sold with print emulsion. Having thus coated our print surface, we are ready to cover it with print emulsion. However, if water has soaked into the canvas or board, then we will coat the surface with print emulsion without using a binder. If we follow the instructions that come with the print emulsion, we can't go wrong. There is only one warning we must heed: Never let the emulsion thicken. If we work on a moistened surface, the emulsion will flow easily and spread smoothly over the surface. If we use a board that is too big, the emulsion will get tacky too quickly and will not join areas together smoothly. If we try to put fresh emulsion over tacky emulsion, it becomes lumpy and is not printable. So, we should use an 11″ x 14″ or a 14″ x 17″ board until we become experienced in emulsion application.

After applying emulsion, we store our board in an empty box for a few hours so that the emulsion can dry. It is wise to coat extra paper beforehand to use for test strips, because we have invested too much time in this project to ruin it with poor exposure. Our test strip is fine, and we're ready to print. The guides are in place, and we view our negative through the red filter with the lens open. Ready to go, lens turned down, timer set, we expose our print for full development as we did the test strip. We develop our print, delicately washing the developer over it; no scrubbing or rubbing, please, for it has a delicate complexion. After full development we wash, fix, and wash again, and then stand, lay, or hang our print to dry. We'll step back and say, "My God, I did it!" All the blobs we made are now covered with the sharp lines and tones of our negative. Now if we wish to do a little painting on top after the print dries, more power to us.

MORE COLOR WITHOUT COLOR

How about another shot at color without color? Years ago when I was a struggling

This black-and-white solarized picture of a fortune teller appeared in another book of mine, but I was sorry I had not done the original picture in color. Therefore, I made several prints on different colors of paper, cut out various sections, and mounted them on a sheet of color-aid paper, which I had sprayed with paint. I then photographed the picture on color film through several filters to see how I could alter the original effect.

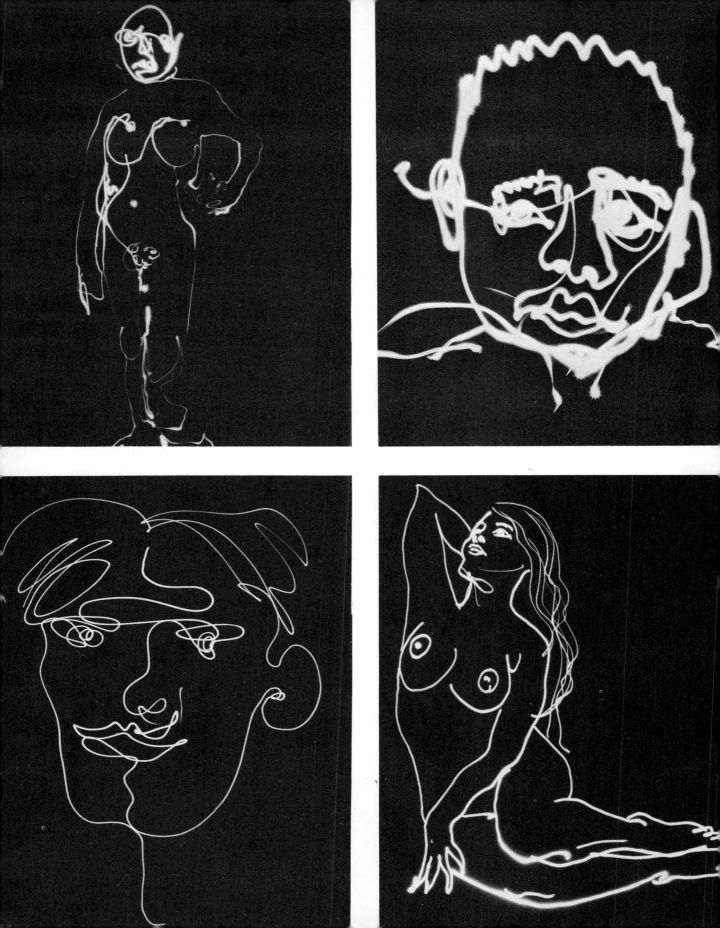

neophyte photographer of dubious talents, I took a portfolio of my best black-and-white prints to show an editor. He picked out one particularly moody picture and said that if I had it in color he would buy it for a cover. A cover! At that time I didn't know anyone who had ever done a cover. Trying to be blasé, I lied to him. "Uh," I said, "I'll look through my transparencies and see if I have the shot." Look through my transparencies! I knew all nine of them by heart (the other three were blanks). Someone had given me a roll of outdated film for my old Rollei. I went back to my studio and considered my situation. Here the Gates of Heaven were being held open for me and I didn't even have a passport. I had some hand-me-down dyes, and I was seriously considering trying to paint my negative when I realized that it *was* a negative and not a positive.

I had a few sheets of Kodalith film around and some A and B developers left over from the big $25 job that I had done the previous year. I contacted my negative and got a Kodalith positive. I decided to first practice with the dyes, so I worked on a piece of yellow gel. The result was disappointing because the dye did not blend well and was

difficult to control. As luck would have it, I turned on my enlarger to see how the gel would look with light shining through it. Also by luck, the Kodalith was in the enlarger, and when I held the gel midway between the lens and the easel, the effect was astounding. I put one sheet of 8" x 10" tungsten color film on one side of a borrowed film holder. On the other side I removed the slide and put an 8" x 10" sheet of paper for focusing. My guardian angel told me that an exposure of 12 seconds at f/22 would give me a cover.

That night I walked into a big, professional color lab like a big-time cover photographer, and handed them my one, miserable, sheet of film to develop. By noon the next day I had made my first cover sale. The editor loved the shot and he never questioned it. He was a good customer until he retired a few years ago.

I'd like to say one thing about picture buyers: they see with their hearts, and they buy end results—not the way a picture was done. If you show an editor a great picture that is grainy or blurred, he will see it for what it is and will not criticize what you might feel are shortcomings. I once heard a photographer apologize for a light streak in a picture that resulted from shooting into the sun. Had he removed the streak, however, the picture would have lost its impact.

TINTED PICTURES

Let's talk about tinted pictures. If you look through the old family picture album, you will probably see some hand-tinted portraits of Uncle Charley or Sonny on a pony; or maybe you even have a tinted portrait of the old folks in an oval, imitation-walnut frame. This is not the kind of tinting I mean. You may take more liberties with your tinting than did your predecessors.

Let's take a nice, contrasty black-and-white portrait of a young lady wearing a big hat. A light touch of rose on the cheeks and a suggestion on the mouth may be all that

Light painting is unpredictable and full of surprises, but it is not as difficult as you think. Here is a collection of light paintings that will illustrate my progress in this direction. Light painting is done by opening the camera lens in the dark and leaving it open while you move a pocket flashlight or other light source to record the image. It is best to use a light with a very small bulb, and experimentation will tell you which aperture of your lens will give you the most desirable line thickness. (A) This was my first attempt at a light painting of a nude. (B) has rather thick lines because my camera lens was open to f/5.6. (C) When I turned down the lens to f/11, I got this head with a fine line. (D) After more practice and learning to turn my light on and off when ending a line, I was able to do the nude.

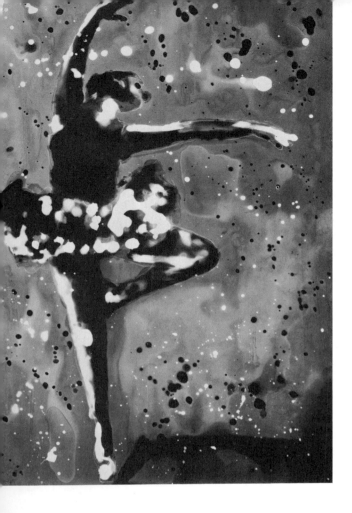

This is a hand-painted negative. I took a sheet of outdated film and projected a negative of a ballet dancer onto it. I sketched the image with pencil, outlining both the shadows and the highlights. I filled three small paper cups with paper developer, hypo, and water. I brushed hypo on the emulsion side of the film where I wanted shadows and let it stand until I could see where it had cleared the film, then I brushed paper developer where I wanted highlights. After the emulsion had darkened, I used the third brush to blend the highlights and shadows together with water. After the solutions dried, I immersed the entire negative in paper developer for about one minute and then put the negative into hypo. I splattered hypo and developer around the background for added texture. Care and practice can bring exciting results.

you need. You may want to tone your picture first and then throw in a little tint. For practice, take a night scene with rich blacks and add a faint touch of blue-green for a cold moon, or yellow for a warm, harvest moon—nothing more. Remember that tinting colors are transparent and will not show over blacks. Judicious use of tints can give your pictures the touch of artistry, while overuse of tints will make you a picture tinter.

5

SOUL

I knew a man who spent thousands of dollars on the most powerful hi-fi equipment he could find and installed large speakers all over his house. Once when I saw him on the street, he was in a rage. He had just come from the hi-fi dealer where he had shouted and told the dealer what he thought of him because the equipment was no good. I couldn't believe it. He invited me over and I brought along a new symphonic record as a gift. I was intimidated by the array of space-age electronics. When he put on a record, out came terrible, scratchy, distorted sound, muddy and lacking fidelity. I was grateful when he turned it off. While we were having a drink he unwrapped my gift record and rushed to put it on the turntable. I gritted my teeth, but I was amazed when out came crystal-clear tones of an unbelievably lifelike performance. It turned out that my friend was playing his old records on his new hi-fi equipment. These records, many of them 78's, were totally scratched and worn out by a cheap, antique set that he had used in college.

The same can be said for photography, my friends. You can own the best, the most expensive, photographic equipment in the world, but you may still get pretty awful pictures if you use outdated film or old chemicals. There are certain rules that must be observed in order to achieve consistent quality. Most rules are flexible, however. For example, if your developer has a recommended development time of six minutes but your negatives are thin, then maybe seven minutes is a better time for you. When we have learned to follow the rules, and the rules are working nicely, giving us good quality, we can start breaking the rules and experimenting.

Where does breaking the rules begin? It begins when a photographer becomes dissatisfied with his limitations and wants to grow—to add excitement, color, design, animation, distortion, allusion, pattern, contrast, mystery, beauty, softness, texture, grain, or comedy to his pictures. Breaking the rules really gets going when the photographer takes the few ideas that I have offered here, and expands them, perhaps takes them in a different direction, and then writes a better book about his methods.

I went to a restaurant one night and got a touch of ptomaine poisoning. That night I dreamed I was being shot from a cannon, so I wanted to do a photograph of someone being shot from one. I photographed a girl on a black background with her feet stuck out in the air, and used a wide-angle lens to distort the figure. I suspended the swirl pattern negative three-fourths of the way up from my easel in order to throw the pattern out of focus and turned the lens to f/16.

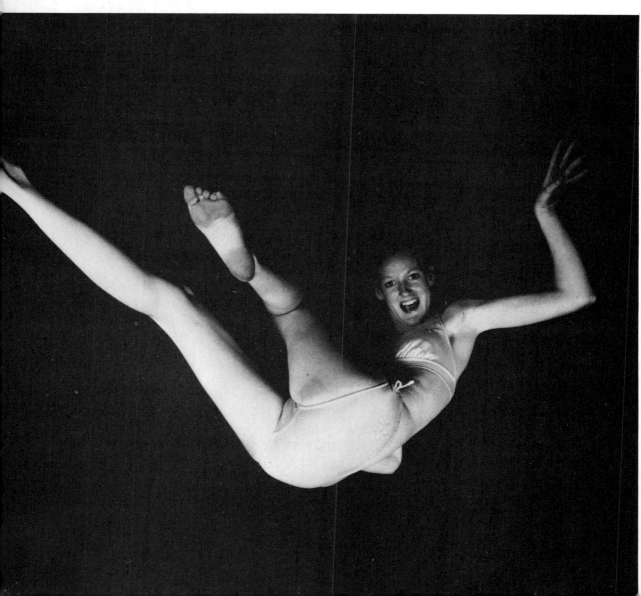

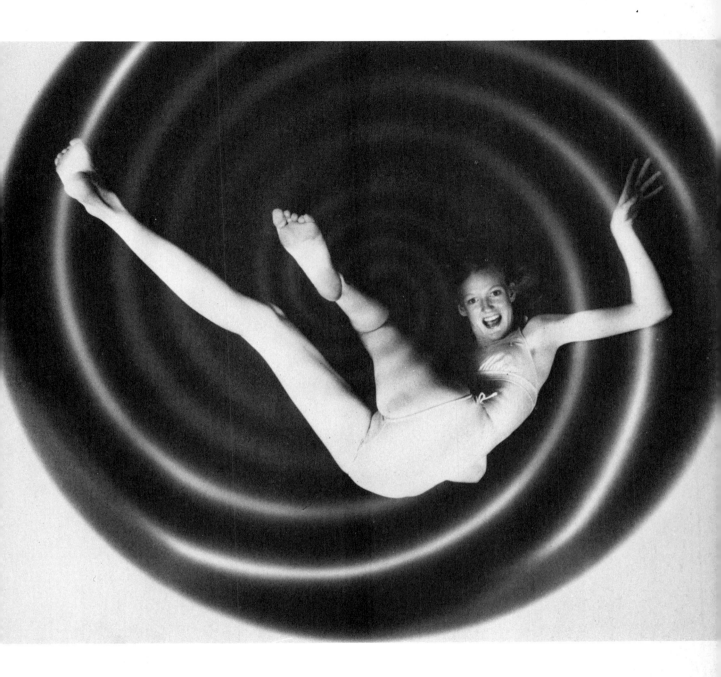

(Left) Reticulation is a very unpredictable technique and can be done in different ways. I developed the negative in the usual way and fixed it in plain hypo without hardener. Then I put the negative in a saucepan with a solution of boiling baking soda (1 tablespoon baking soda to 16 ounces water). I left the negative in the solution for approximately three minutes and watched reticulation take place. I removed it when the emulsion began to slide off the film. (Below) This reticulation reminds me of old Roman ruins when, in reality, it is an old factory building. After I had developed the negative, I fixed it in very hot hypo, then put it in ice water to get this effect.

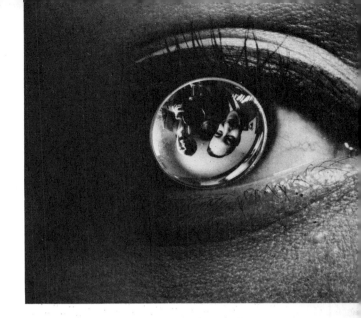

(Right) When I got contact lenses, I thought how interesting it would be if contact lenses were made with two-way mirrors. Before long I found a small chrome reflector about the size of a silver dollar. I placed the reflector on a black background, put a light to one side so that it would light the people in front of it but not the reflector. Then my wife, a friend, and myself gathered around and sat for the picture. I marked the outline of the reflector on my groundglass with an eyeliner pencil, then I made a second exposure of a girl's eye. I tried to get her to hold still so that I could line up her eye with the outline of the reflector. It was close, but our images were upside down because the reflector was concave. I once did a self-portrait by printing my reflection in an old lady's eye.

(Below) In order to save my original negative, I made a copy of it. I developed the copy negative in the usual way, but submerged it in boiling water just before fixing to get this bubbly effect.

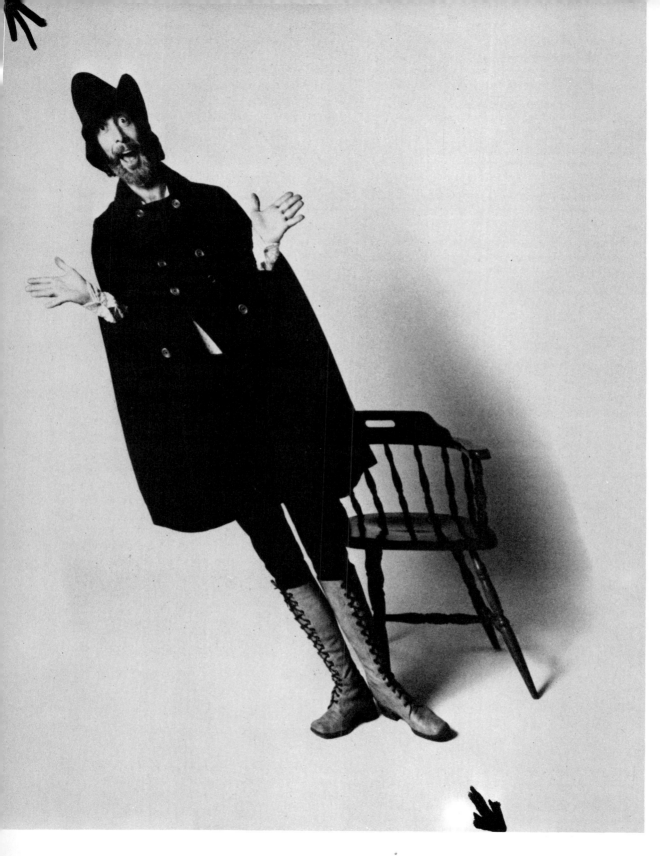

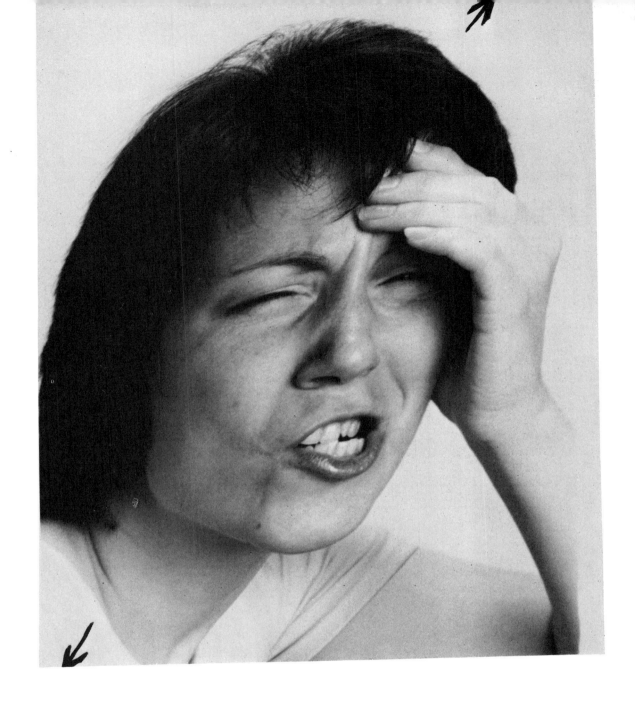

(Left) An anamorphic lens is great for elongating your subject or condensing that subject into a short, fat person. This lens was developed for cinemascope application but is now available to 35mm photographers. I wanted to further explore its possibilities by making double exposures while tilting the subject first to the right then to the left. Here I tilted the man in the cape to the left by turning the lens on its axis. Someone once complained to me that he was unable to focus as close as he wanted, so I attached my lens to a 3× tele-extender and got a picture of the girl with a headache (above). I put arrows on the prints to indicate the position of the lens.

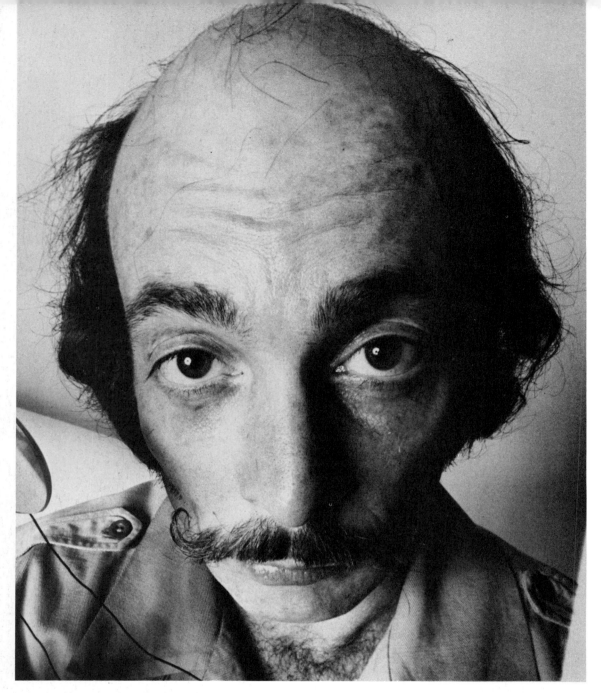

You can take a nice face and distort it into a caricature by using an extreme wide-angle lens very close to the subject. Almost the same thing can be done by tilting your easel so that the subject's chin is closer to the enlarger lens—this makes the chin smaller while increasing the size of the top of the head. During exposure you must dodge the chin area or it will print darker than the top of the head, which is farther away from the lens. I'll let you guess which technique I used here.

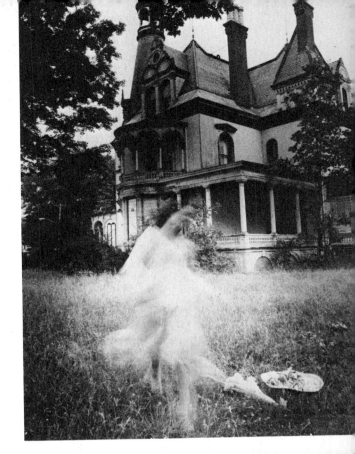

(Right) Most ghost pictures are done by making double exposures—one exposure of the scene with the ghost, and a second exposure of the scene without the ghost. In photographing this old house, I felt that if there were any ghosts here, they would be moving constantly to avoid identification. While I made 1/4 sec. exposures, my wife floated around in her old-fashioned dress, giving me a ghost for my old house.

(Below) In this picture I wanted to show three faces of Shari Richards without making a multiple exposure. Therefore, as she looked to the right I turned on a photoflood bulb for one second; when she looked at the camera I flashed in her face faintly; and while she moved her head to the left I turned on the photoflood bulb on that side for one second. There are many variations of this technique that may be done without having to expose more than once.

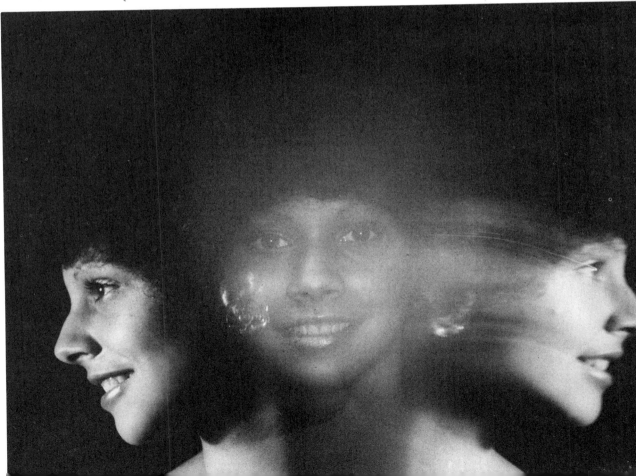

6

A BAKER'S DOZEN

Creative photographers, stand and be counted, for you are among the rare breed of craftsmen whose work is individualized through personal handicraft. As a member of this elite group, I still take pride in carrying on a tradition that I call "A Baker's Dozen."

What I'm referring to are the niceties that used to be so prevalent—like balloons or lollipops for the children; merchants who gave a sample of the cheese or cold cut you were about to buy; a window wash and a tire check with a tank of gas; after-dinner mints at a restaurant; a waiter remembering your name; gift wrappings; a flower for the lady; a drink on the house; or free parking in the rear. I think most people appreciate these things, not because they are free, but because they are thoughtful, convenient, or make us feel important.

PHOTOGRAPHIC NICETIES

In my darkroom I have several boxes full of items that I have coated with print emulsion. You may purchase print emulsion from places like Spiratone stores in New York or by mail order. The emulsion is easy to apply if you follow the printed instructions. Of course, like any technique, trial and error are the shortest distance between two points. I have found certain papers that have the same speed as print emulsion, so I use these for my test strips. I also keep uncoated objects of the same thickness near my enlarger for focusing. In my boxes I keep coated wood of varying sizes and thicknesses, coated drinking mugs, coated buttons, coated can lids, coated hardboiled eggs, and coated plastic items.

PRINTING SURFACES

I am constantly on the lookout for interesting items on which I can print pictures to give to people. I have hundreds of empty 35mm bulk film cans that I use for this purpose. I soak off the labels, then spray paint the cans with bright colors. From time to time I coat the lids of a gang of them in my safelit darkroom and store them in empty 11" x 14" paper boxes to dry. In this way I always have a good supply on hand. Then when I'm making a print of someone special, I expose a picture on a can lid. When the person comes to pick up the prints, I make a present of the can, filled with hard candies. Later the cans may be used for storing paper clips, bobby pins, or other sundries. The present of a can is not such a valuable gift, but it's a nicety that will not be soon forgotten.

I also keep near my enlarger negatives of such things as "wanted" posters, dollar bills, $100 bills, newspaper logos and headlines, magazine logos, calendars, and fancy scroll-work. When I photograph these items, I cut a piece of white paper and insert it on the item and in the spot where I will eventually put someone's picture.

I print many pictures on woodblocks, which people have used in dozens of ways. One girl inserted an eyescrew in a small woodblock that had her portrait on it and wore it on a chain around her neck. One man made a mobile from six blocks that I printed of his wife and family. I have also mounted pictures on larger pieces of wood and hung them on the wall. Of all the strange materials that I use for printing, I find that wood is easiest to coat and is also best for getting a good quality print.

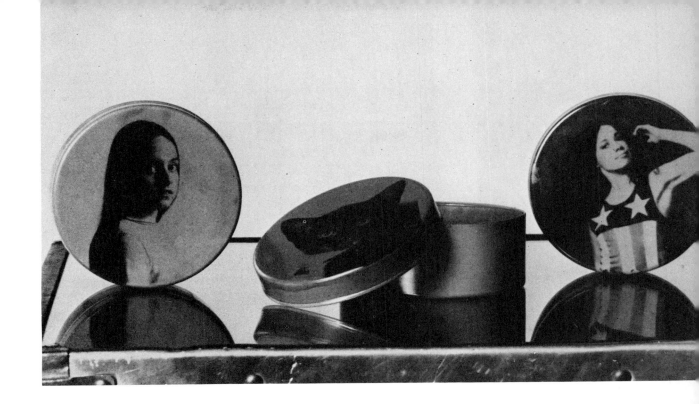

(Above) These lids, taken from bulk 35mm film cans, were coated with sensitive print emulsion. I generally print pictures on the lids and give the cans, filled with candies, to special people. (Below) I photographed a play money dollar bill after I had cut a piece of white paper to cover the center. In this way I had a bill with a blank place to print anyone's picture—in this case my wife, who handles the money in our family and is, I think, entitled to be on one bill. This was printed on green paper to give it more likeness to the real thing.

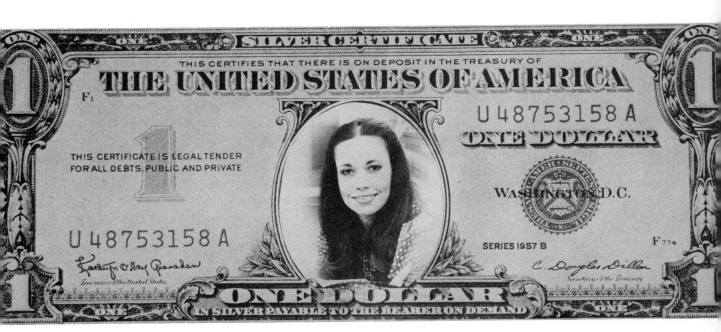

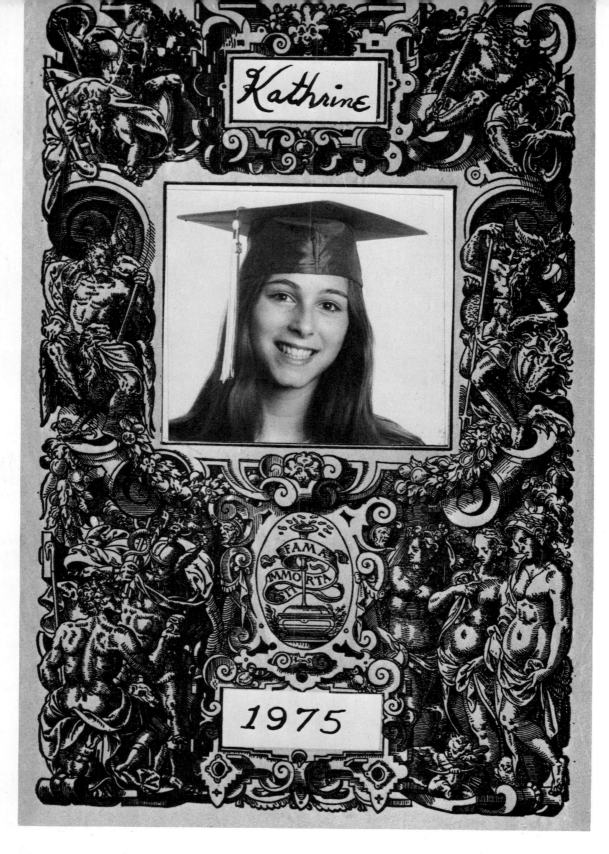

Kathrine

FAMÆ IMMORTA TI

1975

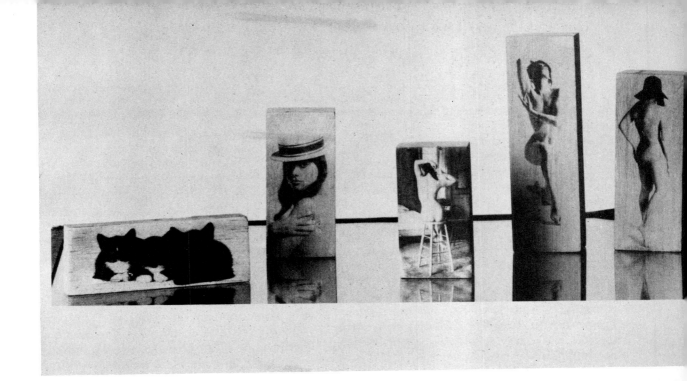

WANTED BY THE FBI
KILLING FEDERAL OFFICERS; INTERSTATE FLIGHT--ARMED ROBBERY, KIDNAPING

FRANCISCO LOUIS MALONEY

DESCRIPTION

Born October 5, 1933, Los Angeles, California (not supported by birth records); Height, 5'5"; Weight, 150 to 160 pounds; Build, medium-heavy; Hair, black; Eyes, brown; Complexion, medium; Race, white; Nationality, American; Occupation, metal finisher; Scars and marks, burn scar inside left forearm; tattoos, temple web of right thumb, "Barbie" inner left forearm, cross, "FM" outer upper left arm.

CRIMINAL RECORD

Maloney has been convicted of robbery, possession of narcotics, kidnaping and escape.

CAUTION

MALONEY, WHO IS BEING SOUGHT IN CONNECTION WITH BRUTAL MURDERS OF FEDERAL OFFICERS, MAY BE HEAVILY ARMED. CONSIDER EXTREMELY DANGEROUS.

(Left) In this picture with the fancy scrollwork, I cut a piece of white paper and inserted it in the spot where I later put this picture of Kathrine. (Above) Here is an assortment of woodblocks that was sensitized with print emulsion. Later, these surfaces were used for printing pictures. (Right) Be sure, when you put people's pictures on wanted posters, that they have a good sense of humor like this model.

If you have a friend who is a politician, don't you think he'd love to see his picture on the cover of *The New York Times* with a banner headline proclaiming, "Landslide Victory"?

For some reason, most people get a big kick out of seeing their pictures on "wanted" posters. Occasionally I drop into the local police station and ask for any old "wanted" posters. They usually have a few to give me for my files. I once printed such a poster on photographic linen. While the linen was still wet, I raveled the edges and poured some coffee over it to give the impression of age. Then I nailed the poster rather taut to a piece of weathered wood and let it dry. My friend found the most prominent place in his den to hang it.

Photographic linen has many uses besides being a texture for printed pictures. I have made many pillows on which I used a portrait for the front panel. A lady I knew used to sew them together and stuff them for me. Some of the pillows were printed in sepia, blue, green, and red toners to make them more decorative. Linen is very good for making small photo patches for blue jeans, jackets, and shirts.

Another product available on the market is an emulsion that makes fabrics photosensitive when they are soaked in it. This process has become so popular that I often see the advertisement "Your photo on a T-shirt."

Photosensitive aluminum is also available, with or without toners, and you can make many decorative mementos on it. Colored photographic papers and aluminum foils may also be used for other, novel applications.

This constitutes some of the "Baker's Dozen" tricks that I do for fun—not for pay, but because I like people. I try to fit the gift to the personality of the receiver. Of course, if some of you want to expand on any of these ideas and turn them into business ventures or merely add to your income, more power to you, but please give a little more than you charge for.

FUN PICTURES

I guess I am a child at heart, for I always have fun with pictures. For years, whenever I made prints for someone and was left with an extra print that had a crooked border or slight variation in print quality, I would take a dry marker and brush up the eyebrows and paint on a mustache; or I might make the subject cross-eyed, or give him a black eye. Instead of being insulted, I found that most people were absolutely delighted.

If you want to be the "life of the party", or at least the most popular photographer on your block, then get out your tools, sharpen your brain, use your initiative, and be daring. Don't be afraid to waste a few pictures, get excited, let your hair down, or have fun. Never say "can't", try your own thing, look for my next book which will probably be titled *Super Tricks,* and smile.

I must assume that you have bought this book as an investment, that you have invested your time, and that you have also invested in a camera and perhaps in darkroom equipment. If all these assumptions are correct, I must also assume that you have made these investments in order to make a career of photography or because you are a serious hobbyist with pride in your efforts. At times, no doubt, a quiet voice speaks, telling you, "The best things in life are free." Nearly so, nearly so. The best you will get from your art form—photography—will come from effort and from a desire to do the impossible. The costs are incidental when compared with the investments already made, and the rewards will be far greater. So now you know that you do not need a red-lined, black evening cape and a tall silk hat to perform magic.

Here is a photograph that was printed on sensitized linen and sewn onto the front of a pillow with yarn.

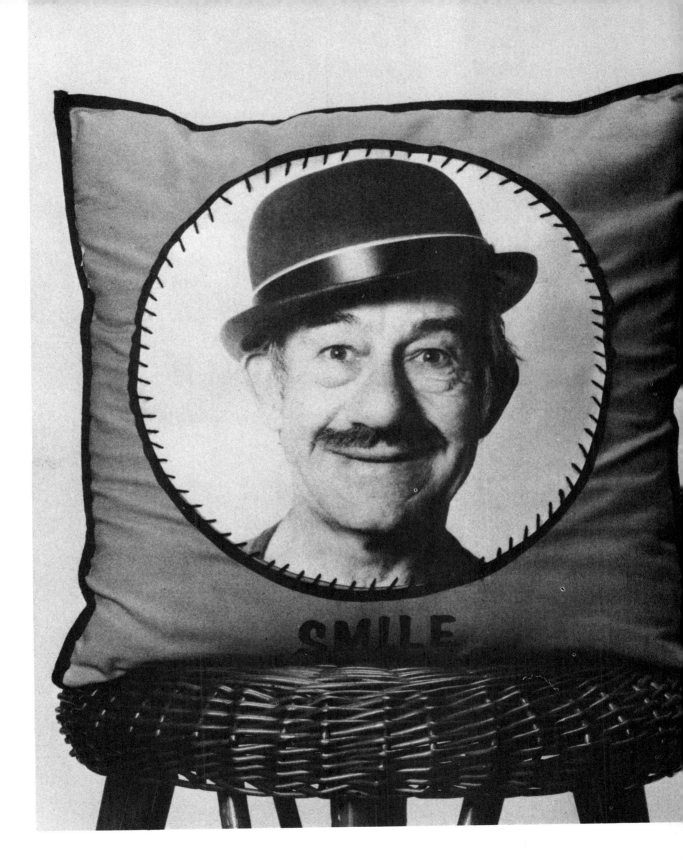

Mother

(Left) The night before my wife's birthday I found myself without a birthday card. I looked through my files for a picture of her that I had never printed. I found this one, which I had never used because the hands were too overpowering. They suited my purpose very well, so I looked for the gold lettering with the word "Mother," which I had pulled off a candy box. I put the lettering at the top of my paper and made the exposure of my wife. Next I exposed a picture of my daughter on one of my wife's hands and one of me on the other. After the print dried, I took a sharp knife and cut along the bottom of my wife's teeth, stuck a $100 bill through the opening, and I had my birthday card. It is shown here without the money, naturally. (Above) This is a bas-relief, made by sandwiching a positive and a negative slightly off-register and making a print. Next I turned on the overhead light very quickly to add an overall gray tone. The final step was a repeat except that I bleached out the hair, the scarf on the model's head, and the eye.

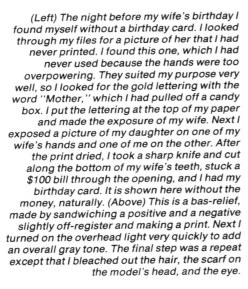

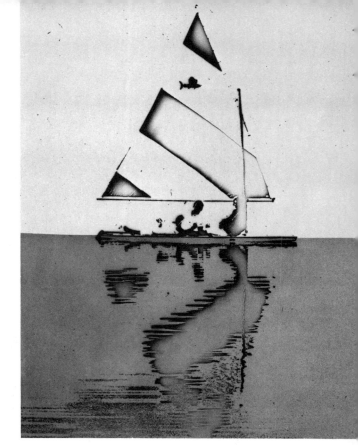
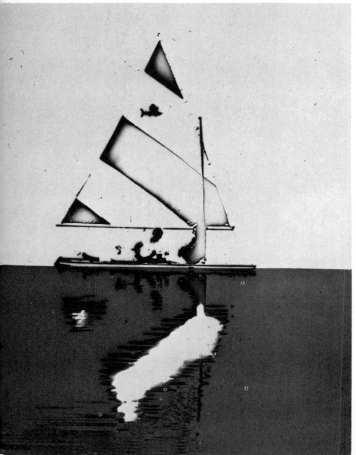
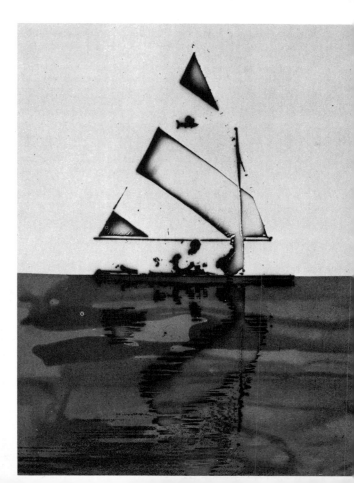

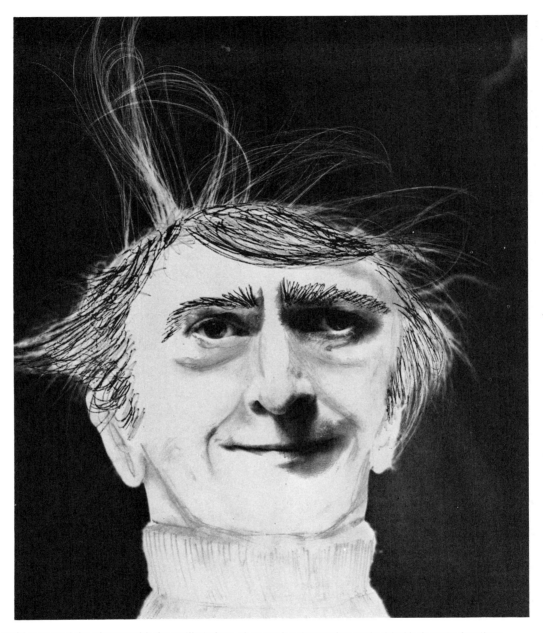

(Above) I repeated the picture with the unlikely face, then took a dry marker and added hair and a few lines to make a cartoon.

(Left) This Repolith negative was solarized during development. Solarization filled in many of the dark areas with light. (A) is a straight print. In (B) I exposed the bottom of the print to room light for a fraction of a second. (C) is the same, except that I bleached out white highlights, and (D) is also the same, except that I brushed the bottom during exposure to get a streaky effect that looked more like water.

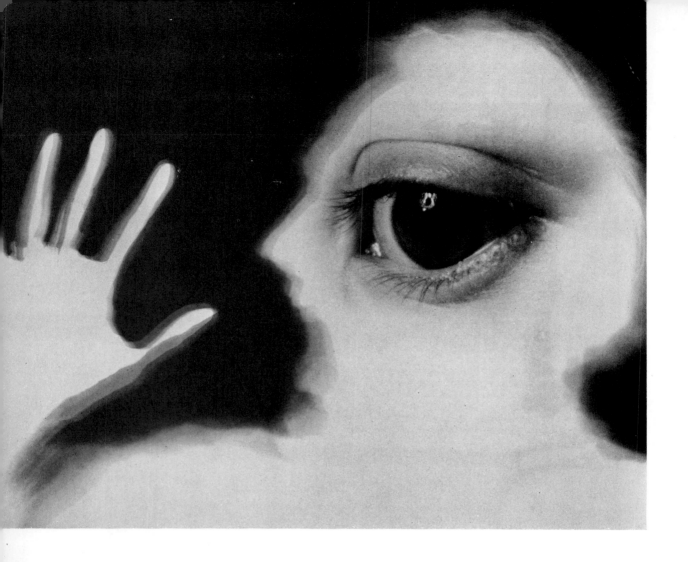

(Above) I have seen so many pretty photograms of girls' heads that are merely pretty silhouettes, so I decided to try some of the same techniques but with more excitement. Since no one was around to use as a model, I put my head and hand on the paper and moved around during the exposure with my mouth open (maybe I was really shouting). After the exposure I put in a large eye of my daughter. The result: Monster from outer space. (Right) This was a reject print that was too dark. For fun I bleached out the face, dried the print, then sketched in this sad-looking face. It is a good way to practice cartoon pictures and caricatures.

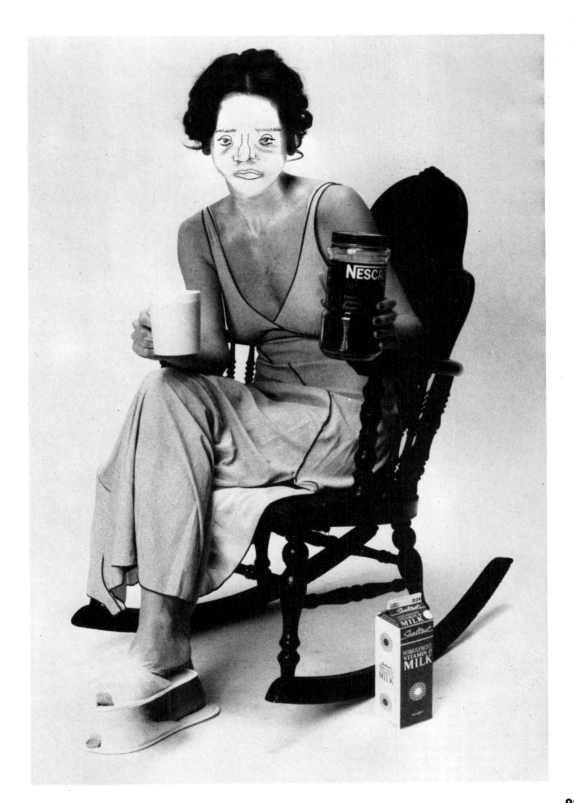

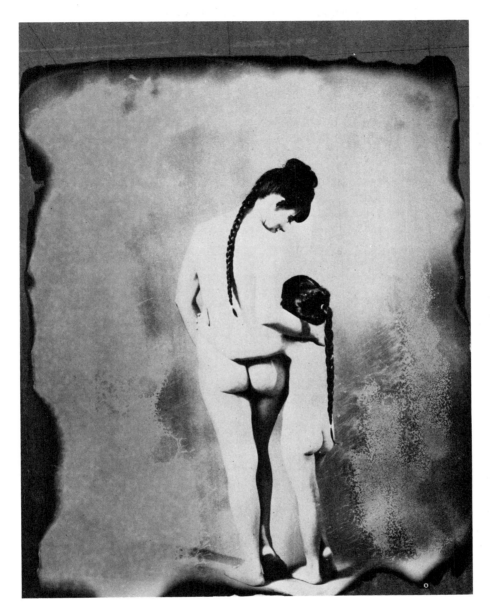

(Above) I made a very high-contrast print of my wife and daughter, then dipped it in a weak solution of bleach to wash out the dark tones. Next I partially fixed the picture so that it would appear stained. After the print dried I burned the edges to bring up the stains for an antique effect.

(Left) In this picture I sandwiched two identical negatives face to face and positioned them so that I could print the same side of the face twice to make a whole, freaky face. This can be done when one side of the face is in shadows, thereby enabling you to use the lighted portions of the two negatives for printing.

(Over) Often, I take extra-large prints into the open to explore picture possibilities. Here's one that I finally crucified on a cross.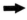

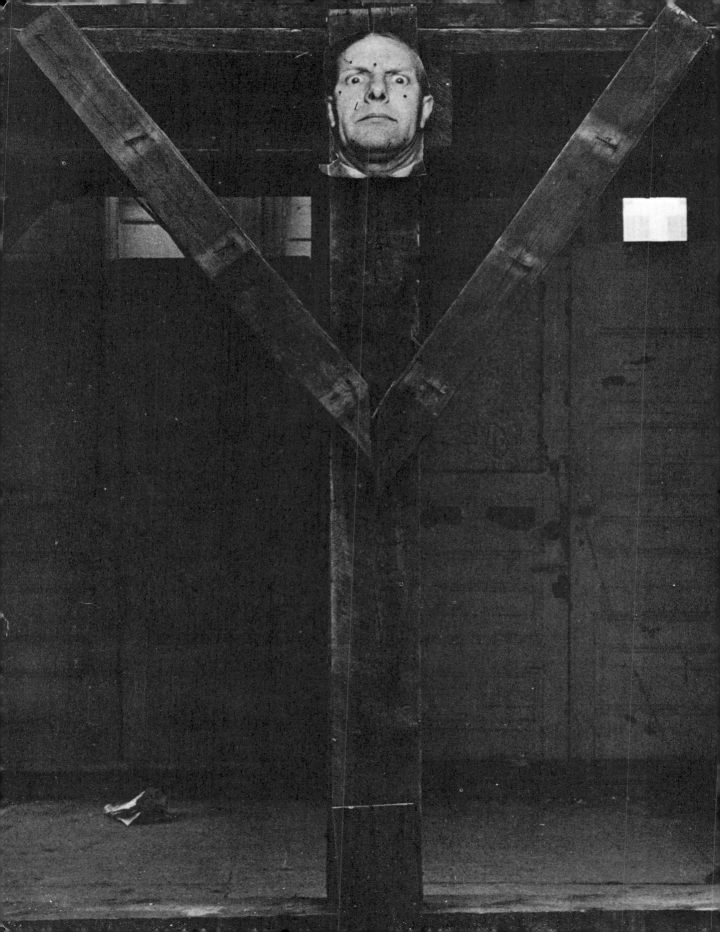